DIGITAL QUICK GUIDE™

P-BY-STEP COMPOSITION ECHNIQUES FOR DIGITAL PHOTOGRAPHERS

D1450638

Ernst Wildi

AMHERST MEDIA, INC. ■ BUFFALO, NY

Published by:
Amherst Media, Inc.
P.O. Box 586
Buffalo, N.Y. 14226
Fax: 716-874-4508
www.AmherstMedia.com

Publisher: Craig Alesse
Senior Editor/Production Manager: Michelle Perkins
Assistant Editor: Barbara A. Lynch-Johnt

ISBN: 1-58428-158-8
Library of Congress
Card Catalog Number: 2004113074

Printed in Korea.
10 9 8 7 6 5 4 3 2 1

TABLE OF CONTENTS

Introduction .5

1. What is Composition? .6
2. Viewing Tools .8
3. Keeping Images Simple .10
4. Viewing Considerations .12
5. Lines, Part 1 .14
6. Lines, Part 2 .16
7. Lines, Part 3 .19
8. The Subject .20
9. Placement of Subjects .22
10. Balancing Elements .24
11. Number of Elements .26
12. Color: Arrangements .29
13. Color: Mood .30
14. Color: Intensity and Harmony32
15. Color: Balance .34
16. Background Color and Brightness36
17. Attracting Elements, Part 138
18. Attracting Elements, Part 240
19. Distracting Elements, Part 142
20. Distracting Elements, Part 244
21. Distracting Elements, Part 346
22. Holding the Viewer's Attention48
23. Black & White Compositions50
24. Highlight and Shadow Areas52
25. Zoom Lens Settings .54
26. Background Area Coverage56
27. Aperture .58

28. Scene Modes .60
29. Depth of Field .62
30. Background Types .64
31. Background Sharpness .66
32. Selecting Background Areas .68
33. Evaluating Background Areas .70
34. Portraits: Composition .72
35. Portraits: Backgrounds .74
36. Portraits: Clothing .76
37. Posing and Composition .78
38. Posing Strategies, Part 1 .80
39. Posing Strategies, Part 2 .82
40. Subjects in Motion, Part 1 .84
41. Subjects in Motion, Part 2 .86
42. Architectural Pictures .88
43. Panoramic Images .90

Closing Thoughts .92
Index .93

INTRODUCTION

The advent of digital cameras has changed the way in which images are recorded, stored, printed, retouched, and creatively enhanced. While it is helpful to learn how photos are created in the digital camera—and to delve into a variety of related topics, like the camera's components, file formats, and perhaps even website design—it is important to realize that capturing a good image in the digital camera requires a solid understanding of the basics of photography, just as it did for film photographers.

Producing a visually effective image requires that you know how to operate the camera and lens so they produce a technically perfect image that's free from distracting elements. To produce anything more than a snapshot, we must have an eye for seeing subjects or scenes that are beautiful, striking, and different from what most other people see. We also must have an eye and feeling for light. We must see scenes or subjects that are made visually effective by the existing light so that everyday subjects are transformed into attention-getting images. We must decide how much of the subject or scene we want to record and determine from what angle it should be recorded so that all the elements within the picture are arranged in the most effective fashion. We must compose the various image elements to keep the eye within the image area and also must select an image format that best presents the subject or scene.

Composition is based on visual rather than technical considerations. Therefore, the text and illustrations in this book are intended to focus on only the artistic aspects of producing effective images (though we'll briefly touch on some technical aspects that will help you to create the best-possible digital images). The book also makes reference to many possibilities for improving digital images in the computer. These techniques are beautifully covered in many books published by Amherst Media and other publishers.

Following the suggestions in the book will lead to better images, and with simply this book in your hand and a digital camera, you have everything you need to produce an effective, well-composed image.

1. WHAT IS COMPOSITION?

■ COMPOSITION BASICS

Composition relates to the choice, arrangement, and placement of lines, shapes, colors, and dark and light areas within the picture's four edges. Often, the point of this is to direct the viewer's eyes to the subject; in other cases, the subject in the picture may actually be secondary, since some successful images may be nothing more than an interesting arrangement of lines, shapes, and colors. Your best photographs may not be images of subjects but visually effective compositions containing designs and colors. Look at subjects or scenes as graphic design elements and search for subject matter with an interesting design and strong visual appeal.

It is also important to realize that while an image may have perfect subject placement and a good arrangement of lines, shapes, and colors, it may include a cluttered background area or a bright white area in a corner that distracts and thus spoils an otherwise good image. Composition, therefore, must include

Successful photographs are often comprised of an interesting arrangement of colors, lines, and shapes rather than specific subjects.

everything that affects the effectiveness and impact of the final picture. This can include key factors like the size relationship between the subject and background, the sharpness range, and the degree of sharpness or unsharpness within the picture.

Composition includes everything that must be considered during the entire photographic process, from the moment the image is evaluated in the camera to the presentation of the final image.

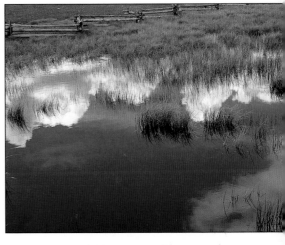

The most successful images are often not overall views as we see them with or eyes but are photos of detailed areas with an interesting arrangement of shapes and colors.

◼ COMPOSITION CRITERIA

Photographs are made for many different reasons and purposes. When making an image for personal reasons—like recording family members or friends or chronicling your travels—the resulting picture should please you and any viewers recorded in your images. Our requirements for such images are few: they should accurately depict the subject with minimal distractions or other technical flaws.

Photographers interested in selling their images or creating fine art have a different set of motivations. Their photographs must be beautiful, unique, and exciting. They must have a visual impact that inspires viewers and should create a desire to see the image over and over again. They should tell a story or send a message. They must also please the viewer.

Creating an effective composition will help you to come up with strong, attention-getting images in the simplest, most effective way. While you'll find numerous chapters on every aspect of composition here, remember that the art of composition requires that you study basic guidelines but apply them only as you see fit. Composition is not based on technical formulas but on visual perceptions, and these can vary from viewer to viewer. Composition is based on artistic guidelines, not technical facts. Once you know and understand the guidelines, you are on your own.

2. VIEWING TOOLS

■ VIEWFINDERS

Most digital cameras come with a viewfinder—a little window through which you look to see and compose the scene that you plan to photograph, just as you did with your film camera. Some people prefer this approach over composing the image using the LCD. You may prefer to do so for familiarity's sake. Also, some people feel they get too wrapped up in the LCD screen when taking pictures—and when they do, they quickly drain their batteries. For this reason, too, the viewfinder may be your tool of choice.

■ LCD SCREENS

LCD screens offer a larger view of the image than the viewfinder. They can also be used to preview a scene before an image is taken or to view the technical qualities of the photo once it is captured. While you can study your intended image on the LCD before pushing the shutter button, it is important to realize that this is not the final image. At this stage, the effects of the aperture and shutter speed do not yet impact the image. However, viewing the image on the LCD will help you to scrutinize the artistic aspects of the shot.

Perhaps the LCD screen's greatest benefit is that it allows you to evaluate the image with both eyes.

Perhaps the LCD screen's greatest benefit is that it allows you to evaluate the image with both eyes. Also, since the LCD need not be in front of your eyes, you can take pictures without making people aware that they are being photographed. However, the image on the LCD screen is somewhat small, and you may find it difficult to determine which view makes the best image. If the subject is promising, record all the good possibilities in the camera so you can decide on the best composition when you evaluate a larger image on the computer screen.

■ CAMERA STEADINESS

When using the LCD screen for viewing and focusing, the camera need not be in front of your eyes. It can be held in one hand anywhere away from the body. However, the camera will likely not be as steady.

The best camera steadiness with any handheld camera is obtained when two forces work against each other in opposite directions. One force is the

hands pressing the camera and the viewfinder eyepiece against the eye and forehead; the other is the eye and forehead pressing the camera in the opposite direction. The meeting point of the viewfinder and the photographer's body becomes the most important point for steadiness. This combination of opposite forces is not obtained when holding the camera in one hand away from the body. This is a good reason for considering the camera's viewfinder for viewing, especially in low-light situations where the shutter speed is fairly long.

■ POST-CAPTURE IMAGE EVALUATION

Once an image is taken, the LCD screen shows the captured image as it was seen through the lens, allowing you to critique all of the aspects of the shot. While a lot can be learned from viewing the image as a whole, many cameras also allow you to zoom in on the image to more closely evaluate the shot.

In bright sunlight, it may be difficult to see the image on the LCD screen. To remedy this problem, shade the screen for evaluation or, if possible, take the camera into a darker area. On some cameras, the LCD screen can be rotated and/or swiveled. You can move such a screen so its image is shaded from direct light, offering a better opportunity for careful photo evaluation.

While the LCD can be used to judge exposure, note that the image will appear somewhat different in a dark surrounding than in a well-lit one. It may also be difficult to see whether the image has sufficient detail in the highlight and shadow areas.

A careful evaluation of the image on the LCD screen or in the viewfinder will frequently provide ideas for photographing the subject from a different angle, from a closer or longer distance, or with a different background. Take the additional picture or pictures if you consider your subject worth the effort.

Digital cameras also give you the opportunity to review a series of previously recorded images. This feature allows you to compare expressions, camera angles, and more. Due to the small size of the LCD or viewfinder, it is difficult to see minor faults in the image or composition or small distracting image elements, so while you may be able to select the best-possible image, delete only those pictures with obvious faults that cannot be corrected using an image-editing program.

3. KEEPING IMAGES SIMPLE

Beginning photographers tend to include too much visual information in a photograph, perhaps feeling that the picture must show everything that they saw with their eyes. This is a good approach for souvenir or "postcard" pictures, where we want to show what we saw with our eyes and let viewers experience the scene in the same way.

To create a more powerful image, remember the phrase "less is more." Most images are visually stronger with fewer elements (often limited to one main subject). Before you take the picture, try to recognize the essential element within the scene and build the composition around it.

In a scene with numerous semi-important elements, try to pare the composition down. Evaluate the subjects or scenes from a closer distance or by zooming in for a closer view of the scene. In a scene with a statue next to a blooming tree, see what the composition looks like with the tree alone or the statue alone. In a picture of an old barn with one door and two windows, try a composition with one door and just one window. In a boatyard with a dozen boats, see whether a composition with only three boats will be more effective.

When you zero-in on a single subject, you will probably find that it can be photographed from a closer distance and from different camera positions,

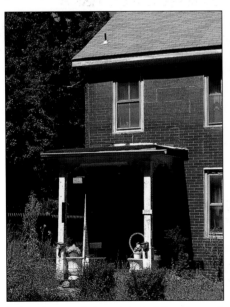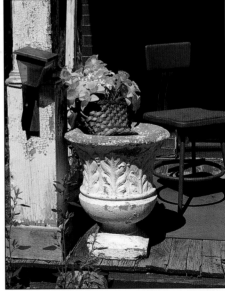

Left—The overall view of the building shows what everybody sees passing by. **Right**—A closer view reveals an interesting arrangement of shapes and colors.

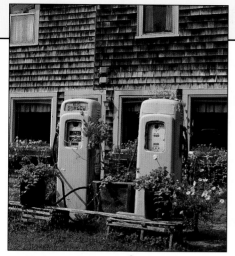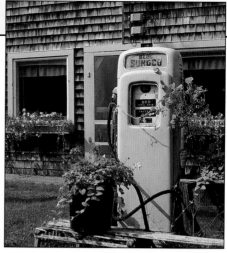

Left—While the two decorated gasoline pumps keep the eye within the picture, the eye also has a tendency to jump from one to the other, and perhaps to the windows on the building, not knowing which is more important. Right—Another composition with only one pump eliminates this problem and makes a visually stronger image.

resulting in a different arrangement of lines, shapes, and colors, with each possibility making a more striking image than the original composition. I frequently follow up the first impression—showing the whole scene—with four or more closer views. I've found that the additional time and effort are well spent. In most cases, the closer views are more interesting to viewers.

Including less in your composition reduces the likelihood of including distracting elements. (Hint: If distracting elements do appear in your image and are close to the edge of the frame, try to eliminate them by cropping the image in the computer.)

■ BASIC COMPOSITIONAL ELEMENTS

The elements that make up a photographic composition are lines, shapes, and colors (or the black, white, and gray areas in a black & white photograph). They must all relate to one another within the picture to form a harmonious arrangement and keep the eye within the picture frame. The principles of composition are easy to learn, and you will quickly be at a stage where these guidelines come to your mind automatically when you evaluate the image in the viewfinder or on the LCD screen. Before long you will be able to select the camera position that makes a good composition even before you frame the scene.

4. VIEWING CONSIDERATIONS

When viewing a photograph or a painting, the viewer's eyes tend to scan the image along similar subject shapes or similar colors. The eye may be attracted first by a red area, then move to the next red area, and to all the other red areas, probably ending up where it started. You may very well have a good composition if all areas of the same or similar color, shape, or brightness are arranged in an effective manner and keep the eye within the picture. The elements in a photograph should not lead the viewer's eye beyond the image area. Rather, the viewer's eye should move easily from one picture element to the next within the print's borders. Good composition and effective subject placement can accomplish this goal.

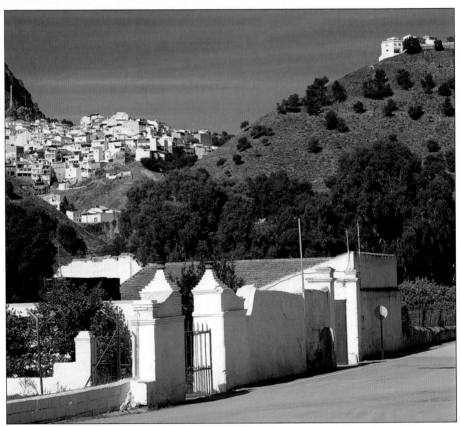

In this picture from Southern Spain, the eye moves from the white buildings at the bottom to the building on the upper right, then to the village in the middle left, and back to the buildings at the bottom.

Above—The shaded area at the bottom leads the eye instantly to the buildings in this image in Spain. **Left**—The eye is attracted first by the bright light fixtures, then moves to the white doorway on the building and along the lighted areas on the ground back to the light fixture.

13

5. LINES, PART 1

Images can consist of straight, curved, or zigzag lines oriented in horizontal, vertical, and/or diagonal directions. The direction of major lines can influence the mood of an image. Compose your photographs so that lines produce an image that is most appropriate to the visual effect you are trying to achieve.

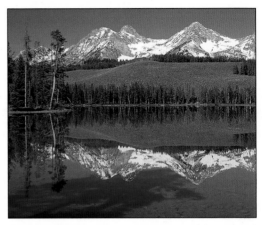

The horizontal shoreline created a peaceful mood and feeling in this photograph, which was taken in Idaho.

■ HORIZONTAL LINES

In any image format, horizontal lines are restful. When a number of horizontal lines are employed in the image, or when horizontal lines cover a large area of the image, the image conveys a sense of peace and calm. Employing a horizontal or panoramic image format can further enhance this feeling.

When shooting a landscape image, you may want to convey a relaxed, peaceful atmosphere. In this case, horizontal lines may help to strengthen the impact of your image.

■ VERTICAL AND DIAGONAL LINES

Vertical and diagonal lines are more active and tend to convey a feeling of motion. They make images more dynamic, especially if there is a repetitive pattern (such as may be the case with a large number of tree trunks in a wooded area or in a display of numerous hanging Christmas ornaments in a marketplace). Diagonal lines can be used effectively for leading the eye toward the main subject in the image. For those of us who read from left to right, diagonal lines are strongest when they go from the lower-left to the upper-right corner of the image.

■ CHANGING THE ORIENTATION

Horizontal and vertical lines within the image can often be changed into diagonals by photographing the subject or scene from a different camera position. When a subject with horizontal lines (such as a fence) is photographed straight

on, it will appear horizontally in our image. Instead, try photographing it from an angle, stepping to the left or right to render the horizontal line as a diagonal. The degree to which the lines will slant is determined by the camera angle, how far to the side we move, and the degree to which we zoom in or out of the scene. Photographing at a wide-angle lens setting from a shorter distance increases the slanting. The image can also be differently oriented (rotated) in an image-editing program to produce an image with more dynamic lines.

Tilting the camera can also change horizontals or verticals into diagonals. Keep in mind that tilting the camera to "force" a diagonal line will alter the orientation of both vertical and horizontal lines. For instance, if you want to turn that horizontal fence in the image into an attention-getting diagonal, you'll also alter the position of the tree behind it to the same degree. In most cases, images created with a tilted camera should look natural. This is usually the case when lines appear tilted in one direction only. Compose such images carefully. If both verticals and horizontals are slanted, the results may look like a special effect or a mistake. Of course, there are times when a "natural" image is far from ideal. When photographing rides at an amusement park, for example, tilting the camera to achieve more dynamic lines can make the image more exciting.

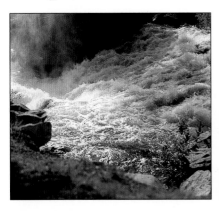

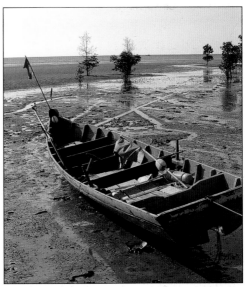

Above—The diagonal composition of the waterfall in the early morning light in Idaho created a dynamic, moving illustration. **Right**—Diagonal lines can be created by photographing stationary subjects from an angle rather than straight on.

6. LINES, PART 2

■ CURVED LINES

Curved lines can add beauty to an otherwise ordinary image. When we spot them in a scene, they often compel us to take a picture. This is especially true for the S curve often found in winding roads or streams.

Curved lines and S curves can be positioned almost anywhere in an image but are most effective when they start at the lower left or right corner and extend diagonally across the scene. The end of a curved line is always a good place to position the main subject, since our eyes have a tendency to follow a curved line into the photo and to stop at the end of the line. For instance, by including a stream that winds from the lower-left corner to a log cabin in the top-right corner of the frame, you'll draw the viewer's eye to the main subject.

■ PLACEMENT OF LINES

A strong horizontal line (like the horizon) or a dominant vertical line (such as a tree trunk) in the center of an image tends to split the photo into two equal halves. This usually does not work to your advantage. It makes the viewer's eye jump from left to right or top to bottom, not knowing which side is more important and where to stop. The disturbing effect is enhanced when

Left—The wooden frame in the center makes your eye jump from left to right, not knowing which side is more important. Right—Placing the center frame in another store window toward the side makes a more effective composition.

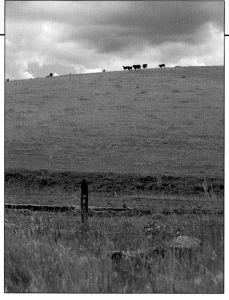

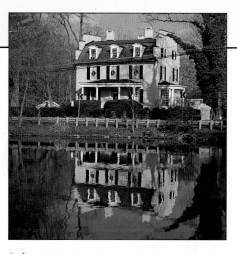

Left—Placing the horizon line toward the top emphasized the relationship between the large green field leading up to the sky and the small cows at the top edge of the field. **Above**—Placing the dividing line in the center emphasizes the repetition of the actual subject and the reflection.

such lines cross the entire image area. Placing the horizon in the center of the image seldom works—not even with a beautiful sunset or cloud-filled sky!

Practically all images are improved by placing the dominant horizontal line toward the top or bottom, or placing a dominant vertical line toward the left or right. The placement then depends on whether the top or bottom, or the left or right side, of the image is more important. In a sunset picture, you may decide to place the horizon closer to the bottom if the cloud formations are exceptionally beautiful, or place it toward the top if the reflections on a water surface are more interesting. The exact line placement depends on the content of the image. You can, however, hardly go wrong by considering a position about one-third from the right or left side, or one-third from the top or bottom of the photo in any image format.

Center Placement. There can be exceptions to the above-suggested line placement. There are cases where a strong dividing line in the center of the composition is most effective. I almost invariably use this approach in scenes where a subject is reflected on the water's surface. Placing the dividing line— the line of the water's surface—directly in the center seems to emphasize the repetition between the actual subject and its reflection in the water. I could also visualize a tree trunk in the center if there is a repetition in subject matter on the left and right side, perhaps two smaller identical trees on the left and right, or two identical houses in the distance on both sides of the tree.

17

7. LINES, PART 3

■ ATTRACTING AND DISTRACTING LINES

Lines that attract attention must be avoided if they are not important in the composition, might lead the eye to an unimportant area in the image, or could distract from the message that we are trying to convey.

Any line that goes in a different direction from most or all the others in the picture is likely to attract attention. In a color image, a line of a different color attracts attention. Such lines can be helpful if they are part of the main subject or lead the eye to the main subject.

Avoid dominant lines of a different color or going in a different direction from most of the other lines in the image if they are not important to the composition. Watch for dominant lines or subjects that extend into the border on any of the four sides of the image. The point where the line or subject cross-

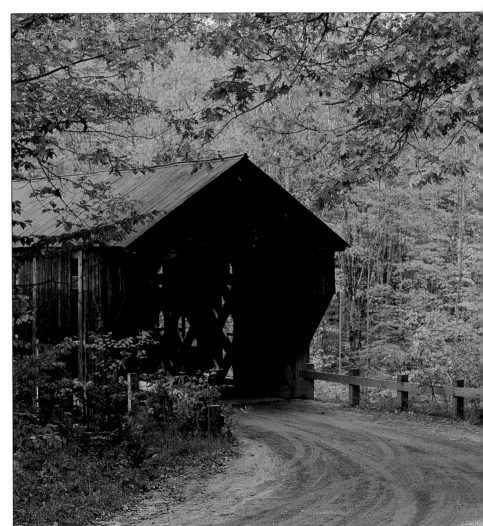

es the border creates unnecessary attention and may make the viewer's eye leave the picture completely, which is the last thing that you want to happen. See lesson 20 for more on this topic. Finally, a viewer's eye is also attracted to the point where two lines going in different directions intersect.

◼ SLANTED LINES

Lines that we are accustomed to seeing as verticals or horizontals must be recorded that way in the picture if they are not to be distracting. A slanted or crooked horizontal line can be especially distracting—particularly in a horizontal or panoramic image. Watch the horizon line carefully when composing the image in the camera. Slightly tilted horizons in the captured image can be straightened in the computer.

Left—The image was composed to take advantage of the beautifully curved road leading the eye toward the covered bridge. **Above**—The diagonal line of the church steeple, created by tilting the camera, makes a more dynamic image.

8. THE SUBJECT

■ IMAGES WITH A MAIN SUBJECT

Good images are usually made up of one main subject. This subject is the focal point of the image and is complemented with secondary, less important elements. An image of a flower bed, for example, could include a dominant rock; an image of sand dunes could include a figure or an old tree; and an image of fall trees could consist of all yellow trees with the exception of one that is bright red, which then becomes the main subject. Placement of this main subject and placement of secondary elements (see lessons 9–11) within the picture frame must now become the main consideration for composition.

Most compositions include one main element that attracts the eye, with possible secondary elements that balance the composition. This image was taken in late-afternoon sunlight.

■ IMAGES WITHOUT A MAIN SUBJECT

Images do not need to feature a main subject. They can be created with nothing more than a repetitive arrangement of identical or similar shapes and colors over the entire image area. Such an image has no beginning and no end but can be full of life. Good examples of this image type include a bed of flowers or a summer meadow with different-colored grasses, weeds, and flowers; a hillside with rows and rows of fruit trees; sand dunes in a desert; and an image of fall colors with nothing more than brown, yellow, red, and green leaves filling the frame from top to bottom and left to right. The effectiveness of such images lies in the repetition of the same or similar elements and/or colors within the picture frame. The different elements and/or colors must be spread in an effective fashion over the entire image area for a visual balance. For more information on this topic, see lesson 9.

Successful images may be nothing more than an interesting arrangement of lines, shapes, and colors without a specific main subject.

9. PLACEMENT OF SUBJECTS

■ CENTERED SUBJECT PLACEMENT

A centered subject placement creates a somewhat static feeling, but it works when a single subject is photographed in front of a plain background or an outdoor background without any elements that draw attention. Examples for center placement may include a single building, a vase of flowers or a plate of fruits, and a portrait with the person looking directly into the camera. Central placement of the main subject can also be considered when picture-enhancing elements in the background are of the same type or color and appear on both sides of the main subject.

■ OFF-CENTER SUBJECT PLACEMENT

When a person or animal that you want to photograph is looking to the left or right, leave more space in the direction of the subject's gaze. The same suggestion can be made for a still life of a vase with flowers if all the flowers in the vase bend to one side and with subjects that seem to be moving—a swan in a pond, a sailboat on a lake, a bird flying, or a child running. In each case, you should give the subject more space in the direction in which it seems to be moving or leaning.

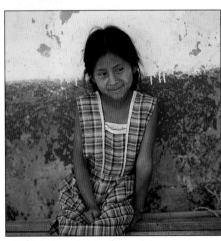

Above—Portraits with the people looking directly into the camera in front of an understated background call for center placement. **Right**—This subject called for center placement since the two trees provided a frame on both sides.

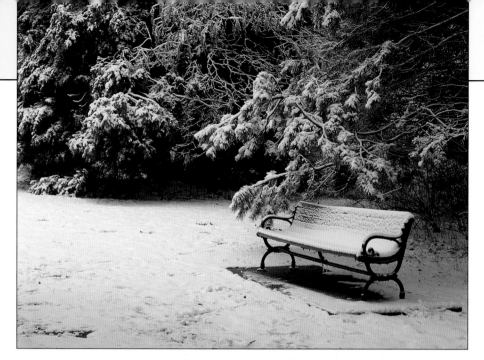

Composing the bench to one side made the image more dynamic, especially since the snow-covered trees beautifully fill the image area on the left.

■ DYNAMIC SUBJECT PLACEMENTS

Placing a main subject off center, toward one side, or near the top or bottom of the frame usually creates a more dynamic image. The most effective position for the subject depends on the location of the other elements in the photo.

To find a good placement for any type of subject in any image format, you can use the Rule of Thirds. First, visualize a horizontal line one-third from the top of the frame and another one-third from the bottom of the frame. Next, visualize two lines that vertically cut the image into thirds. (With the four lines dissecting the frame, the result should resemble a tic-tac-toe grid.) The four points at which the lines intersect are referred to as power points and are good places for positioning your main subject. You can hardly go wrong by placing a distant church or old barn surrounded by fields and trees or a boulder surrounded by ferns at any one of these four points. Which point to choose depends on the rest of the elements within the picture.

You can also place horizontal main subjects such as a fence, a tree laying on the ground, or a horizontal rock formation along either horizontal line approximately one-third from the top or bottom of the image. Place a vertical subject such as a tree, flagpole, smokestack, or telephone booth approximately one-third from the left or right edge of the frame.

10. BALANCING ELEMENTS

With the main subject placed off center, the composition must be enhanced with image elements on the other side of the main subject to provide the necessary visual balance to the image.

Balancing elements can be of any type and shape. You can choose to balance the subject with the same or a similar subject, shape, or color, or you can choose

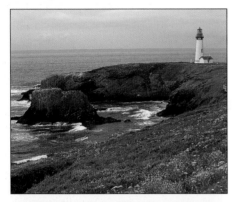

a secondary element that is different from, but related to, the main subject. When including balancing elements in the frame, be sure that they are meaningful and are effectively positioned in the frame. Other ⅓-placement points within the picture are usually good choices.

In a rectangular or panoramic picture, you need to utilize a balancing element in the area of the frame that is opposite the subject; for instance, you'd include a balancing element on the left when the main subject is on the right. Some images can be further improved by balancing both the other side as well as the top or bottom of the image. An old barn on the upper right might be effectively balanced with a portion of an old fence at the bottom left. The fence is now a balancing element both horizontally and vertically.

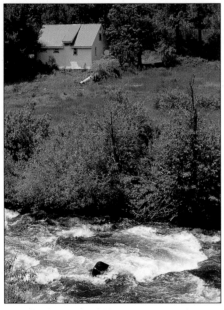

■ COLOR

In color pictures, the most effective balancing elements are those that are of the same color as (or similar in color to) the main subject. This is because the viewer's eyes tend to scan the image for similar or identical colors,

Top—The lighthouse in Oregon was placed at the upper right since the waves at the lower left formed the necessary balance. **Above**—The building on the upper of the image left balances the stream at the bottom since both have the same color.

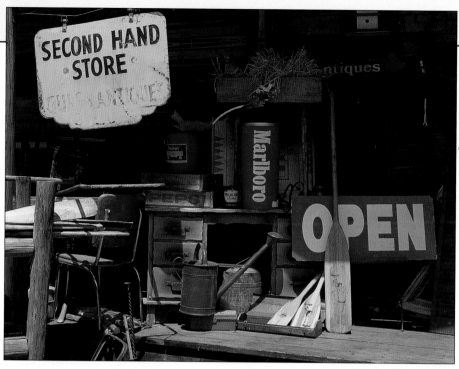

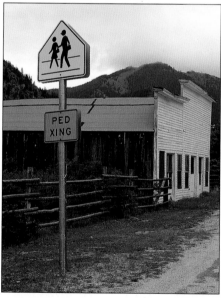

Above—The front of the antique store was composed so that the yellow paddles on the lower right balance the yellow sign on the upper left.
Left—Balancing elements need not be similar or identical to the main subject, as in this picture in Montana where the wall of the building and the road on the right balance the pedestrian sign on the upper left.

moving, for example, from one red subject area to all the other red areas within the picture (and probably ending up where they started).

■ SUBJECT SHARPNESS

When considering the balancing elements, consider also the degree of sharpness with which the various element will be recorded in the camera. Since the main subject is undoubtedly sharp, the balancing elements should usually be reasonably sharp. A completely blurred secondary subject may attract unnecessary attention, especially if it is the only blurred subject in the picture.

11. NUMBER OF ELEMENTS

Designers and decorators have said for years that an uneven number of elements is always better than an even number. A landscape designer's blueprint will probably show three birch trees or three identical bushes, not two or

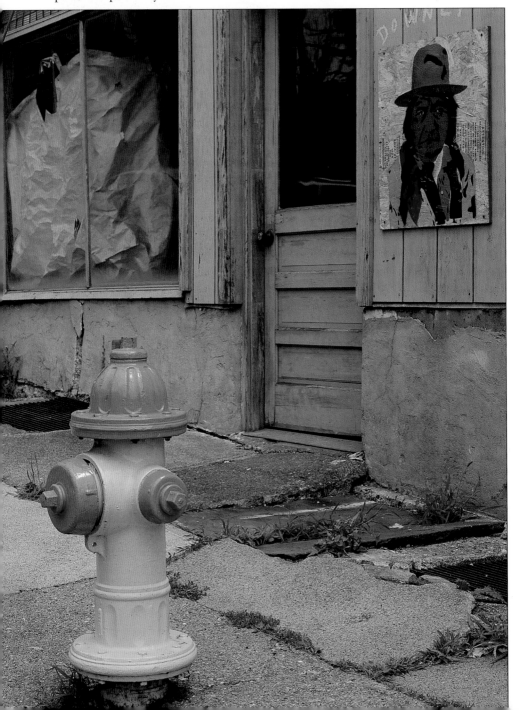

Facing Page—The hydrant, the main subject, is placed to the left since it is balanced by the artwork in the background on the right. **Left**—Two subjects of more or less equal importance—in this case, the desk on display at the lower right and the artwork at the upper left—make the eye jump back and forth. **Right**—In this unfortunate case, two subjects of more or less equal importance make the eye jump back and forth, not knowing what the picture is to show.

four, in a given landscape design. Uneven numbers always work well in photographic compositions, too. You can hardly go wrong with one main subject and two secondary subjects placed properly within the image area. The viewer's eye is then attracted first by the main subject, then travels to the second and third secondary elements and back to the main subject. Three elements are generally easy to compose and arrange in any format.

■ SECONDARY SUBJECTS

Remember that any balancing elements that are employed in the scene must appear less important than the main subject. They must be smaller, less interesting, and less noticeable. If a balancing element is of equal importance to the main subject, you will essentially have two main subjects in the frame, both competing for the viewer's attention—and this seldom makes for a good compositional arrangement.

While it is usually good to feature a secondary subject less prominently in an image, there are times when you should disregard this "rule." This can be the case when you want to emphasize the sameness or similarity of two subjects, like two identical doorways, or two identical flowerboxes. In such a picture, you want the viewer's gaze to jump from one subject to the other.

12. COLOR: ARRANGEMENTS

Effective images can be created by nothing more than an effective arrangement of colors within the image area. The subject itself may then be a secondary element in the composition. Such images can be effective either because the colors are similar, complementary, or contrasting, conveying the feeling that they fight with each other. Interesting shapes in the different colored areas can add further impact to such images. When looking for picture possibilities, don't just look for subjects. Always keep your eyes open for color arrangements. The possibilities exist everywhere.

Successful images are often the result of an interesting arrangement of colors, lines, and shapes rather than specific subjects.

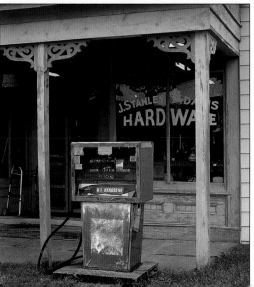

Above—This photo was created primarily with one color but was made more effective by the early-morning lighting, the dark background, and the fog along the top of the image. **Left**—I can see two reasons for taking a picture like this; one is the uniqueness of the gasoline pump in front of the old hardware store, the other is the wonderful harmony between the color on the pump and the color on the building's wall and pillars.

13. COLOR: MOOD

Different colors convey specific moods. Blue tones are considered cool colors and convey that mood in the picture. Cool colors have a tendency to recede. Reds and yellows are warm colors, giving the viewer a feeling of warmth and pleasure. These colors also have a tendency to motivate or to advance in the image. Green and gray are passive colors that are easy on the eye and create a restful feeling.

Black backgrounds create a somber mood. White is the color of joy and innocence. Keep in mind, however, that a viewer's eye has a tendency to be attracted by the brightest areas in an image—especially if the bright area is next to a dark area. White next to black always attracts the eye, regardless how small the areas might be.

Facing Page—This is an image composed to motivate with the complementary colors of blue in the roofs and yellow in the flowers. **Above**—A gray sky enhanced the mood and feeling of the cold and foggy January day when the American Falls of the Niagara River were photographed at a relatively slow shutter speed.

14. COLOR: INTENSITY AND HARMONY

■ INTENSITY OF COLORS

The intensity of colors can vary from saturated to pastel. The brightness and saturation is determined by the color of the subject itself as well as by the lighting. Sunlight provides brilliance, saturation, and contrast. For example, red can look brilliant in sunlight but more pastel in the soft light of an overcast or a foggy day.

■ COLOR HARMONY

Wherever colors are used—in photography, art, decoration, or attire—color harmony should be considered. We try to wear a jacket that harmonizes with the color of our slacks or select a tie that harmonizes with a jacket and shirt. Color harmony needs to be considered when decorating or painting a room or house as well.

Colors that go well with each other are often of similar shades, such as brown and beige. Other colors, like blue and yellow, are complementary. When they appear together, they create contrast and are mutually enhanced. Still other colors clash when combined and convey an uncomfortable feeling.

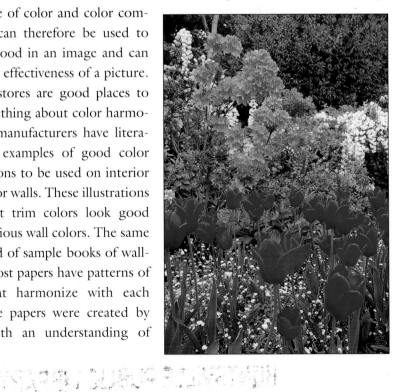

The choice of color and color combinations can therefore be used to create a mood in an image and can impact the effectiveness of a picture.

Paint stores are good places to learn something about color harmony. Paint manufacturers have literature with examples of good color combinations to be used on interior and exterior walls. These illustrations show what trim colors look good against various wall colors. The same can be said of sample books of wallpapers. Most papers have patterns of colors that harmonize with each other. The papers were created by people with an understanding of color.

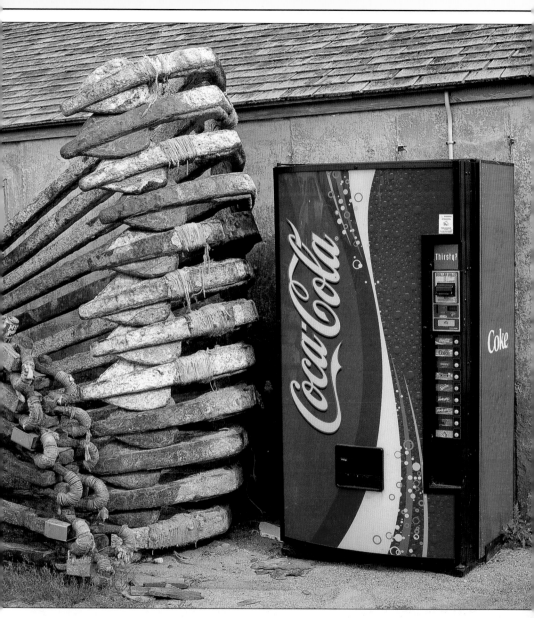

Facing Page—The contrast between the white, red, and pink flowers created an effective composition of an otherwise ordinary subject. Above—I can see two reasons for taking a picture like this: one is the uniqueness of a modern Coca-Cola machine in this surrounding, the other is the color harmony between the bright machine and the dull colors on the building wall and anchors.

15. COLOR: BALANCE

The importance of creating a balance in the composition was discussed in lesson 10. In a color image you must try to achieve this balance with colors. Most images call for balancing subjects of the same or similar color as the main subject, not just a subject of a similar shape. In an image with an arrangement of all the red apples on the left and all the green apples on the right, you may have a good composition of shapes but not a good balance of colors. To achieve a balance of colors, you must repeat the red on the right, perhaps by placing at least one red apple among the green apples. A small orange boat on the top left of the image frame can be a good balance for a large red boat at the bottom right. However, it is important to note that very bright subjects seldom make good balancing elements as they are likely to attract too much attention, especially when these areas are large. They draw the viewer's attention and may become the main subject.

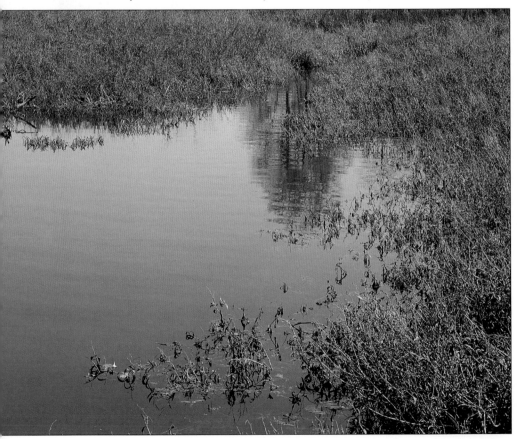

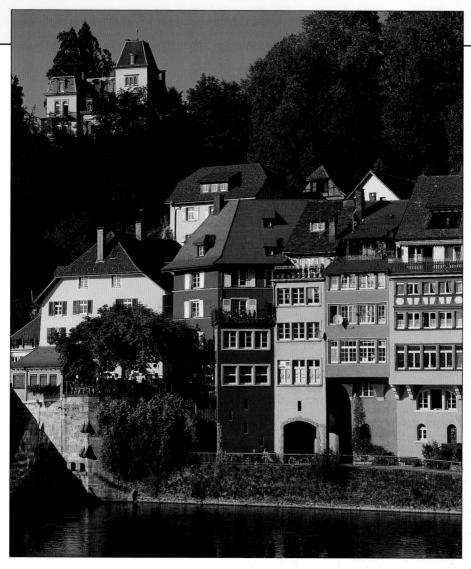

Facing Page—Composing the swamp area to include the brown weeds on the lower right give the picture the necessary balance of color. **Above**—The building on the upper left creates a wonderful balance to the buildings on the Rhine River on the lower right, especially since both have the same color and texture.

Since the choice of balancing elements is almost unlimited, you should seldom have a problem making an image with a well-balanced composition. Look at the subject or scene from different angles, from the left or right, perhaps from different distances or by zooming in or out. A different angle or a smaller or larger area of coverage can usually bring a balancing element into the composition.

16. BACKGROUND COLOR AND BRIGHTNESS

Backgrounds are an important part of most of our images, so their type, color, and brightness must be an important consideration. Backgrounds can be chosen to harmonize with the main subject, to become part of the main subject, or to form a strong contrast to the main subject. Since a viewer's eye is attracted to bright areas, bright backgrounds can distract from the main subject just as a white mat or border can distract from a framed black & white or color photograph.

■ SELECTING THE BACKGROUND

When shooting indoors, we can sometimes select the type and color of the background and light it in a specific way to create the desired brightness and effect. While we cannot actually create the background in location pictures, we have many possibilities for photographing our subjects against a background that adds impact and effectiveness to the image. We have practically unlimited possibilities far beyond what we can achieve indoors. This is especially true for candid or formal people pictures and is a good reason for making portraits outdoors.

In one and the same location, we can often include different background areas simply by changing the camera position. We may be able to photograph the person or other subject against backgrounds of different colors or against a lighter sunlit area or a darker, shaded background. By zooming in or out, we can change the size of the included background area. The degree to which the lens is zoomed in or out, the lens aperture, and the distance between the subject and background can allow us to capture backgrounds with a different degree of sharpness. If none of the above suggestions result in a satisfactory background, you can add practically any type and color background post-capture with most image-editing software.

In one location, we can often include different background areas simply by changing the camera position.

Since backgrounds in people pictures are so important, this topic is discussed in more detail on pages 74–75.

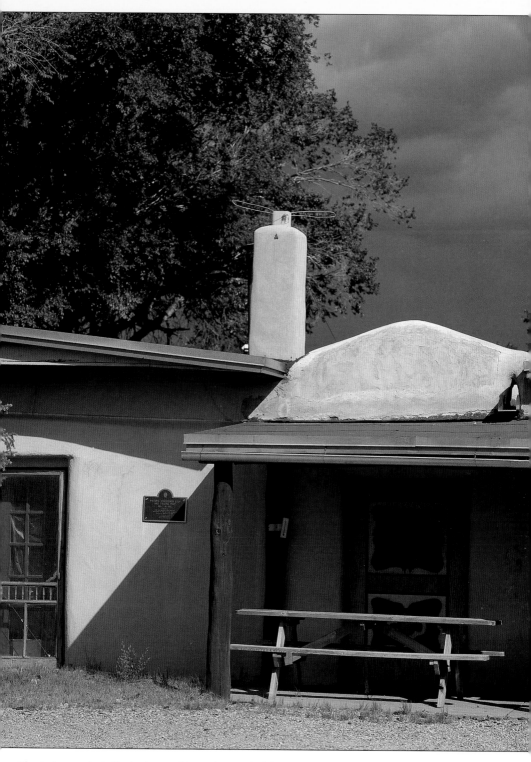

The dark-gray sky in the background formed a wonderful contrast to the brightly lit foreground; this was my reason for taking this picture along a highway in New Mexico.

17. ATTRACTING ELEMENTS, PART 1

The viewer's eye is always attracted by specific elements within a picture, especially when such an element is the only one of its type in the image. The elements that attract the eye are:

1. **A subject that looks different from the rest.** In a parking area with a number of automobiles and one motorcycle, the eye is probably attracted by the motorcycle.
2. **A bright area.** Bright areas attract attention in both color and black & white images, even if they are small. A bright reflection on water or on the chrome part of a motorcycle can attract the eye.
3. **A subject that has a different color.** In a flower bed full of red tulips and one yellow tulip, the viewer's eye will likely go to the yellow tulip first. In a picture of a tree-lined road with a red stop sign at the end, the sign attracts attention, even if it is quite small in relation to the trees.
4. **A subject that has a different shape.** In a picture with several round apples and one banana, the eye goes first to the banana, even if the apples have the same yellow color as the banana.
5. **A subject that is of a different size.** In a group picture with four adults and one small child, the child attracts attention.

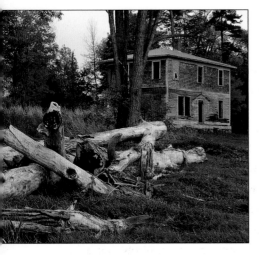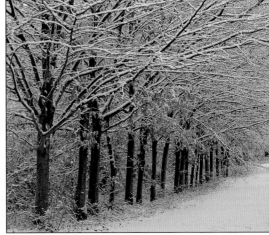

Left—The tree trunks attract the eye since they are bright and are the only picture element that runs in a diagonal direction. **Right**—The dark tree trunks become the main subject as they are the only dark elements in this winter scene in New Jersey.

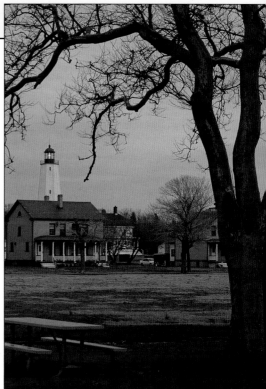

Left—This scene in Virginia City, MT attracted my attention because the barbershop sign was the only bright-colored subject in a dull surrounding. **Right**—This image taken in Sandy Hook, NJ, was composed with the tree framing the lighthouse, which attracts attention as the lighthouse light is the only bright subject in the picture.

6. **A subject or line that goes in a different direction.** The small trunk of a broken tree laying diagonally in the midst of gigantic vertical tree trunks attracts attention since it is the only element going diagonally.

7. **A subject that is recorded in the camera in a different way in regards to image sharpness.** In a picture of a small stream flowing through a large area of rocks and stones, the eye undoubtedly goes to the moving water if the water is recorded with a blur.

8. **A subject that doesn't blend seamlessly into the scene.** Such a situation may come up especially in digitally manipulated images. If the digitally manipulated or added portion looks in any way different from the rest of the image, it will attract attention. This can help the visual impact of the image, or it can destroy an otherwise good photograph.

18. ATTRACTING ELEMENTS, PART 2

Two things can and must be learned from the observations made in the previous section:

- Since one-of-a-kind subject elements attract the eye, they make ideal main subjects in any picture. Such elements can also be used to guide a viewer's eye to the main subject or where they help the composition in other ways. You can only fail if there is something else in the picture that attracts even more attention for some reason.
- Try to eliminate one-of-a-kind elements if they have no connection to the main subject, and do not include such subjects or areas in addition to the main subject. They may and probably will attract the eye more than the main subject will. This statement does not mean that secondary elements can never be of a different shape, size, color, go in a different direction, or be different in some other way. They can, but they

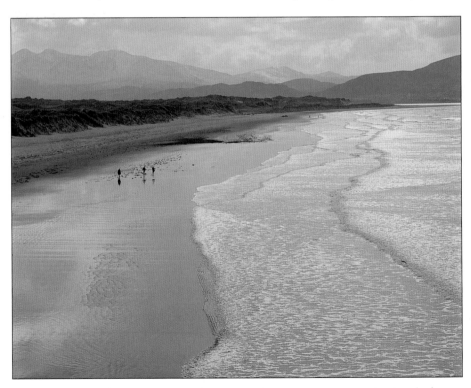

While extremely small, the people in the water attract the eye because they are dark elements next to a bright part of the image and because they are the only elements of a different shape.

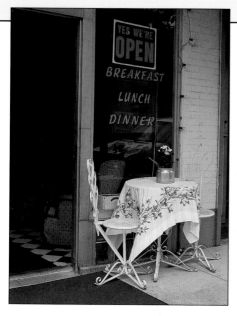

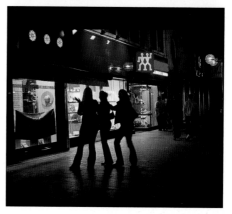

Above—Limiting the composition to the doorway with the table and chair makes this a typical image with a one-of-a-kind subject element that attracts the eye. **Top Right**—The structure on top of the hill was the main reason for taking this picture in New Jersey, but the visual effectiveness in the picture is created by the dark rocks and the shadow that was created by the back light (light falling toward the camera that illuminates the back of the scene). These elements draw the eye toward the structure. **Bottom Right**—The three girls attract immediate attention as the dark figures are composed against the brightest area in the background.

must not be dominant. A line leading to the vertical main subject can be diagonal. The lines of a distant mountain range can go horizontally and/or diagonally behind a line of vertical trees.

The points discussed on pages 38–39 must be considered when composing the image in the camera. Consider them again when evaluating the final image. Such an evaluation of the final image will not only assure you of the most effective photograph but will probably also make you more aware why some images are more successful than others and why some images attract and hold attention while others seem to lack this necessary ingredient.

19. DISTRACTING ELEMENTS, PART 1

The visual impact of a photograph is achieved only when it is free from elements that distract from the image or whatever message it is supposed to convey. All the previously mentioned elements that create attention become distracting elements if they appear in the wrong fashion or in the wrong part of the composition. Assure yourself that these attention-creating elements do not appear in a distracting fashion in your pictures.

■ BRIGHT AREAS

In color and black & white images, a viewer's eye is always attracted by bright areas, almost regardless of how large these areas are and where they are within the composition. A subject that is just of a brighter color than the others may not be a problem, but white areas almost always are. White areas are especially distracting when they are next to dark areas. The dividing line between white and dark becomes the main attraction.

Skies can be very bright, and large, bright sky areas are almost always objectionable, perhaps even disastrous in any type of outdoor picture. Try to compose outdoor scenes so they do not include large white sky areas.

When necessary, bright, distracting image elements can also be darkened in the computer.

■ OBJECTIONABLE VIGNETTING

Darkening the corners of the frame, called vignetting, is an approach often used in portrait photography for keeping the eye within the picture. This can help to draw attention to the person's face and may help to convey a more polished image. Be careful, however, to limit the darkening to a point where it is hardly recognizable, does not attract attention, and does not distract from the enjoyment of the portrait. Vignetting is a special effect and, like all special effects, should never attract attention. Vig-

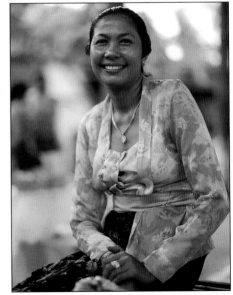

An otherwise good portrait in Bali is ruined by the bright sky area on the upper right.

netting may very well become objectionable if the darkening extends into the subject area, perhaps making the person's arms and hands darker than the face. Artificial darkening is especially unacceptable in outdoor portraits where the backgrounds must look natural. This effect can be easily accomplished in most image-editing programs, where it can be carefully controlled.

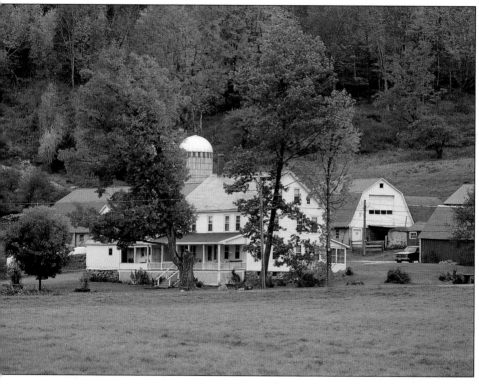

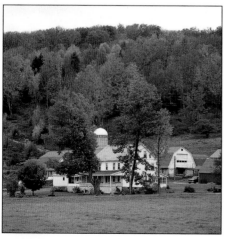

Left—The bright white sky area at the top edge of the image distracts and must be eliminated by cropping the image in the computer. **Above**—After cropping, the results are much improved.

20. DISTRACTING ELEMENTS, PART 2

■ BORDER-CUTTING ELEMENTS

Bright sky areas can be exceptionally objectionable because they are not only bright but are usually at the border of the image where they tend to lead the eye out of the image area. This happens not only with sky areas but any important line that cuts into the border of the photograph, any object that is partially cut off by the border, as well as with any line or part of a subject that comes into the picture area from the outside. The point where the line or the subject meets the border always attracts the eye. This can also happen if the subject is very close to the border without actually cutting into it.

The point where the line or the subject meets the border always attracts the eye.

A picture with a church steeple cut off at the top can hardly become a prizewinner, nor can a picture with the tree trunk cut off just above the ground level, thereby losing its footing and appearing to be floating in the air. A small white house in the distance may be a perfectly natural part of the composition when we see the entire house, but the same house can be awfully distracting when cut in half by the border. A person among a group of people, or a horse in a group of horses becomes a main subject when cut off by the border, even if that subject is darker than the rest.

A border-cutting element need not be large or dominant to attract the eye. It may be nothing more than a dark or white line. Our eyes tend to follow the line, then come to an abrupt stop at the point where the line crosses the border, then stay there or continue moving out of the picture area.

Watch also for border-cutting elements that come into the picture from the outside such as a tree branch, an arm, or a leg. Such elements distract not only because they cut the border but also because they seem to come from nowhere.

When evaluating a scene in the viewfinder or on the LCD screen, and also when evaluating the final image, look all around the border and watch for any type of distracting elements that are close to the edge of the image or are actually cutting into the border of the image.

Such elements can often be eliminated by cropping the image in the computer.

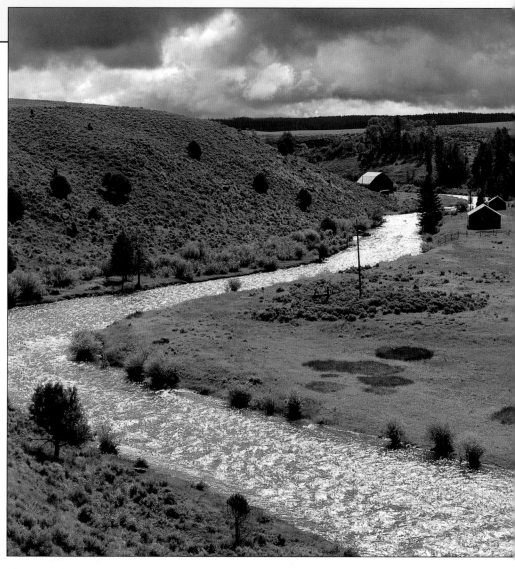

The point where the stream cuts into the border on the left becomes the center of attraction and ruins the picture.

21. DISTRACTING ELEMENTS, PART 3

■ TECHNICAL FAULTS

A photographic image can be enjoyed only if it is free from obvious technical faults, the most obvious being underexposure with a lack of detail in shadow areas (the image is too dark), overexposure with washed-out highlights and colors (the image is too light), and unsharpness over the entire image area caused by camera motion or improper focusing.

A few other obvious technical faults that become distracting and are therefore worth mentioning are:

- Reflections from a flash on a shiny background.
- Red pupils in people's eyes caused by the flash reflecting off of the retina. (To prevent this, use your camera's red-eye setting or correct the problem in the computer.)

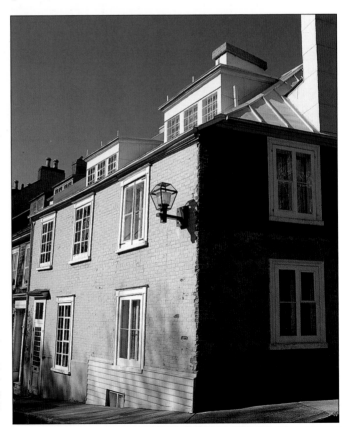

The slanted lines in this photograph of a beautiful building in Quebec City distract from the enjoyment of the image and must be considered a technical mistake.

Technical perfection requires that vertical lines that we normally see as vertical and parallel are recorded in this fashion in the final image.

- A portrait that is overpowered by flash, resulting in washed-out skin tones and colors.
- A photographer's reflection or shadow appearing in the picture.
- Lines that should be horizontal or vertical but are not.
- Images with an insufficient or excessive range of sharpness (depth of field).
- Soft-focus effects that look more like an overall image blur.

Many of the technical faults discussed above can be corrected using digital imaging software. While this is so, I still recommend that you try to produce as technically perfect an image as possible in the camera.

22. HOLDING THE VIEWER'S ATTENTION

Keeping the eye within the picture is one of the basics of composition with any subject in any type of photography. Making a composition that places elements along the border of the image can prevent the eye from moving out of the picture. Almost any subject can serve this purpose. Trees are the most popular solution in landscape photography. The tree trunk prevents the eye from moving out of the left or right border. Branches can often do the same at the top of the image. Buildings, rocks, and mountain slopes offer similar possibilities.

Whatever subject is used for this purpose, it must be darker than the main image area. It then serves as a natural vignetting device for darkening the sides or corners of the image. Make certain that this element does not divert the viewer's attention and that there is no bright area between the subject, the tree trunk, and the border. It might attract the eye even if it is small.

Facing Page—The church steeple is composed using trees on the left and right to prevent the eye from moving out of the image area. **Above**—The tree in Southern Spain prevents the eye from moving out of the picture. A smaller palm tree on the left makes a good compositional balance.

23. BLACK & WHITE COMPOSITIONS

Black & white images can be created directly in some digital cameras or they can be made in the computer from digital color images. In either approach, you do not have the dynamic range that you may be used to from black & white film photography, nor do you have the wide contrast control that you have in film developing and darkroom printing.

■ LIGHTING

Effective black & white images can be created by an imaginative arrangement of lines and shapes that are either black, white, or different shades of gray. More

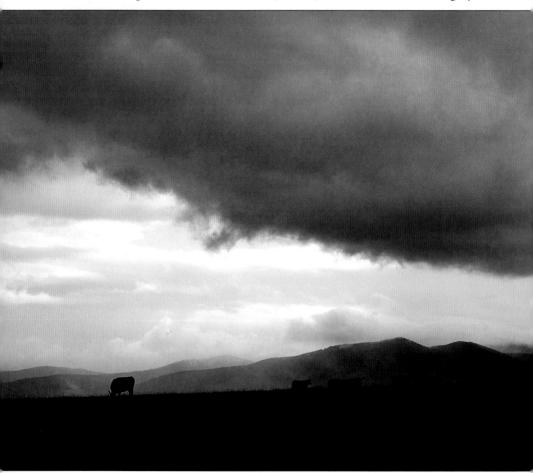

Successful black & white compositions are often made up entirely of an interesting arrangement of lighted and shadow areas.

Effective lighting is an important requirement for great black & white images. Light coming from behind the subject created this interesting interplay of highlights and shadows.

often, the effectiveness of black & white images is not only created by the arrangement of the different subjects but by the lighting. Different types of light, coming from different directions, place some subject areas into the light and others into the shade, adding another dimension to the image. The effectiveness is then created more by the contrast range. Many black & white photographs are completely created with light, with the effectiveness of the composition determined mainly by the arrangement of lighted and shaded areas. Lighting can add a tremendous visual impact to black & white portraits and make them more original and more artistic. It can add a touch of fine-art quality.

■ POSTERIZATION

In image-editing programs like Adobe Photoshop or Adobe Photoshop Elements, black & white images can be made to look completely different by eliminating the gray tones and making an image that consists of blacks and whites only. The best results will be achieved when you apply this effect to a graphic subject with an interesting and distinct shape, since any hint of texture in the image will disappear.

24. HIGHLIGHT AND SHADOW AREAS

■ TECHNICAL CONSIDERATIONS

When we look at subjects or scenes with our eyes we can see details in bright as well as dark, shaded areas practically regardless of how high the contrast range may be. As a result, we also expect to see details in the shadow and highlight areas of a color or black & white photograph. However, the tonal limitations of photographic recording media make it impossible to reproduce the tremendous contrast range that we can see with our eyes and that exists in many locations. We can have a photographic print with details in the shadow areas but nothing visible in the highlight areas or a print with details in the highlight part

The contrast between bright and dark areas makes many black & white pictures effective.

but absolutely nothing visible in the shadow areas. Neither print looks satisfactory. Shadow areas are just black, highlight areas are washed out.

■ EVALUATING THE CONTRAST

Look at the contrast range in the subject or scene. If it includes distracting bright and dark areas, check whether one or the other can be reduced or eliminated by changing the composition or by cropping the image in the computer.

Try to do this especially if either the dark or the bright areas cover a large portion of the image. A careful image evaluation on the LCD screen can help, especially since there is no formula that tells you what contrast range a camera can bridge with satisfactory results.

■ SHADED AREAS AS PART OF THE COMPOSITION

Shaded areas can be used as a compositional element in black & white or color images. The shape or outline of a shaded area can add an interesting compositional element. Such a case came up while I was traveling in the northern part of Spain. The late-afternoon sun left everything in the shade except a few

houses and a church on top of a steep cliff. The dark, shaded cliff formed a beautiful diagonal line leading to the lit houses and church, which I composed on the upper-left corner of the image.

In another case, in New Zealand, a snow-covered mountain range in the distance was separated from autumn-colored trees in the foreground by a completely shaded hill that formed a diagonal line from the upper right to the lower left. The dark, backlit hillside separating the foreground and background also served as an effective background for the bright-colored fall trees.

■ SHADOWS

Shadow patterns can become a part of the composition. A shadow can even be the main reason for taking a picture. A lamp fixture or a decorative store sign like those found in many places in Europe may form an interesting diagonal shadow pattern on a building wall. The shadow may become the main element or may just add impact to the picture as it leads the eye to the main subject, like the sign or lamp.

Shadows on the ground can also be used effectively as part of the composition. The direction of the light is important. When the main light source hits the front of the subject, the shadows lead away from the camera and are seldom effective. With light coming from the side, shadows from trees, people, or other subjects go to one side or diagonally and are more interesting and

The diagonal shadow lines were the main reason for taking this picture in Rhode Island. The shadows added a unique touch and pictorial element to the picture.

more dynamic, as all diagonal lines are. The most interesting composition is usually achieved when the light comes from behind the subject. When the sun hits the back of the subject, the shadows fall toward the camera, thereby enhancing the three-dimensional aspect of the scene. Such shadows can be used beautifully to lead the eye toward the main subject. The shadows coming toward the camera can be changed into diagonals, if desired, by simply moving to the left or right of the main subject.

25. ZOOM LENS SETTINGS

Azoom lens can be used to enhance your composition—without moving physically closer to or farther from your subject. Instead of trying to include a more satisfactory background area by changing the camera position, you might find that zooming in or out provides an equally good or even better image by changing the background size and sharpness. This is important, since such changes are impossible or very difficult to achieve post-capture.

■ THE STANDARD LENS SETTING

A zoom lens set to standard (the default setting) records a three-dimensional subject or scene pretty much as we see it with our eyes in regards to the size relationship between the foreground and background. A barn in the distance

that we see as being about $\frac{1}{10}$ the size of a closer building will be recorded in about the same size relationship in the camera. This size relationship is known as perspective. Use the default lens setting when you want to show a subject or scene as people normally see it.

■ IMAGE PERSPECTIVE

While you can create wonderful photography using the default lens setting, zooming in or out can offer additional possibilities and may make it simpler to achieve an effective composition. This allows us to change the size relationship, the perspective between the foreground and background elements and between the main subject and the background.

Facing Page—The default (or "normal") setting on a camera records a scene as we see it with our eyes in regards to the size relationship between subjects at different distances. **Above**—Including the rocks in the foreground enhanced the three-dimensional feeling in this wide-angle picture taken in Idaho.

Photographing at wider lens settings reduces the size of more distant subjects, making them appear to be farther from the foreground. For example, a barn in the background may be just a small, hardly recognizable element at a wider setting. Photographed at a telephoto setting, the barn may cover the frame from top to bottom, becoming a rather dominant part of the image. The size relationship is directly proportional to the setting of the lens. You may decide on the size of the background subject strictly from a visual point of view, or the decision may be based on the purpose of the picture or what the image is to convey. In either case, make it a habit to evaluate the image created at different focal lengths.

26. BACKGROUND AREA COVERAGE

◼ WIDE-ANGLE VS. TELEPHOTO LENS SETTINGS

The lens setting (a wide-angle setting, a telephoto setting, or somewhere in between) determines the area that will appear in your image. For example, pictures taken at wide-angle settings include a larger background area behind a main subject. This helps to establish a location, emphasizing where the picture was taken.

At telephoto settings, the background area is reduced and blurred and is made less visually important in the scene. By selecting a telephoto setting, you can also eliminate objectionable or distracting subjects in the background such as cars, people, advertising signs, and sky areas. With the importance of the background diminished in this way, the emphasis is placed on the main sub-

Facing Page—The background area with the blue sky that a short focal length included is confusing. **Above**—A longer focal length lens limited the background area and made the statue more dominant.

ject. In the telephoto setting, moving the camera a little to the left or right, or up or down, can dramatically change the background area.

27. APERTURE

Lenses have a built-in diaphragm that opens and closes like the iris in our eyes does. In bright light, the iris closes to reduce the amount of light that reaches the retina; in darker surroundings, it opens wider to let more light into the retina. The lens diaphragm does exactly the same in the digital camera.

The main reason for changing the diaphragm opening is to produce properly exposed images, regardless of whether you photograph in bright or dark areas. In most modern cameras, the aperture is adjusted automatically. It closes to a smaller opening in bright light but opens wider in darker surroundings so that the sen-

A tripod was necessary since the f/22 lens aperture necessary to have depth of field from foreground to background required a slow ⅛-second shutter speed.

sor receives the amount of light that produces a properly exposed image. Many digital cameras also give you the option of adjusting the aperture manually.

The size of the diaphragm opening is indicated by aperture values with high numbers (such as f/16), indicating a smaller opening letting less light to the sensor or lower numbers (such as f/4), which means that the diaphragm opening is larger and will let more light hit the image sensor.

For most of your pictures, you want to set your camera to the automatic exposure mode where the camera selects the aperture and shutter speed setting for the subject or scene being photographed. This automatic mode produces good exposures with most subjects and in most lighting situations. If your camera offers exposure modes for different subjects, such as snow, beach, fireworks, etc., use that setting since it is likely to produce the best exposure for that subject. The snow or beach setting, for example, compensates for the very high reflectance from the snow or sand.

For more serious work (or with high-contrast subjects, back lighted subjects or scenes, silhouettes, when photographing sunsets or sunrises, or when the scene includes large shaded areas, large white sky areas, or bright reflec-

tions on water), you may want to make the settings manually if this is possible on your camera. If you plan to use the manual exposure mode, study the camera's instruction book to learn how the metering system in your camera works and how metering systems must be used to produce the ultimate exposure in all lighting and subject conditions.

Portraits usually look better when taken at a large aperture that diffuses the background. You may want to use the manual mode or aperture-priority setting so that you can select the aperture yourself.

28. SCENE MODES

■ AUTOMATIC

For most of your photography, you will probably use the camera in the automatic or program mode, in which the camera automatically determines the aperture and shutter speed required to produce a well-exposed image. However, most cameras also offer a host of other modes, with varying shutter speed–aperture combinations that can be used to create a more professional or artistic image.

■ APERTURE PRIORITY

Selecting this mode allows you to precisely control the depth of field in the photograph. When you select the aperture you need to get the desired effect,

With large, white, open-sky areas, or large white clouds in the sky, you may find that using the automatic mode results in underexposed images. By using the manual mode, you can ensure success.

the camera automatically selects the shutter speed required for the proper exposure.

■ LANDSCAPE

In this mode, the camera chooses a narrow aperture to produce a wide depth of field. This mode can be effectively used in scenic and landscape images, where sharpness from the foreground to the background is desirable.

■ PORTRAIT

In the portrait mode, the camera will select a wide aperture to produce a narrow depth of field. This is useful for people pictures and other photos where you want the subject to stand out from the background.

In low-light situations, as inside this mission in Idaho, the camera's metering system provides correct exposure, but the shutter speed may be too long for handheld photography. Support the camera on a tripod.

■ MANUAL

When working in the manual mode, you can select both the aperture and shutter speed as you like. This provides the greatest degree of creative control over your image.

29. DEPTH OF FIELD

In addition to affecting the amount of light that enters your lens to strike the image sensor, your choice of aperture affects the depth of field, or the distance range within which subjects will appear sharp in the final print. At a small aperture (a high aperture number like f/16), the range of sharpness is large. It is reduced by setting the lens to a larger aperture (a lower aperture number like f/4). You can set the aperture yourself if your camera provides the option to work in the manual mode or the aperture-priority mode (see lesson 28).

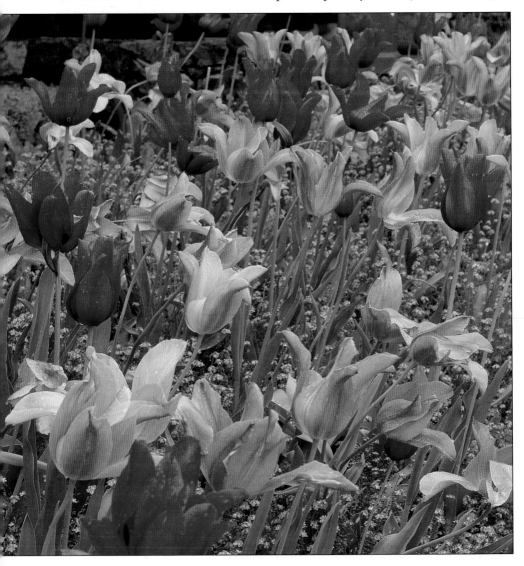

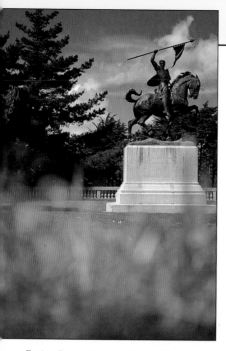

Facing Page—Compositions without a main subject are usually most effective when everything within the image area is sharp. **Above Left**—Limiting the sharpness range provides wonderful opportunities for creating images that look different from the way we see the world. **Above Right**—Foreground subjects with definite outlines like the arches look best when recorded sharp. Set the lens so the depth of field extends to the foreground subject.

■ HOW MUCH OF THE IMAGE SHOULD BE SHARP?

What part of an image should be sharp and what parts should be blurred, and to what degree, is usually based on personal preference. As a general rule, subject elements that are important and have well-defined, sharp outlines usually look best when they are sharp because that is the way we see the scene with our eyes. In people pictures, on the other hand, backgrounds are often more effective when they are blurred and thereby emphasize the main subject.

The LCD screen on a digital camera can be used to see the approximate sharpness range and how sharp or unsharp backgrounds and foregrounds are, but only once the image has been taken. If you want to get an idea of the sharpness range and background sharpness before you take the image, you must close down the lens aperture manually if this is possible on your camera. However, since the image on the LCD is small and the screen's texture makes it difficult to see fine details, it is not easy to see at what point the sharpness changes from acceptable to unacceptable. The problem can be overcome, at least partially, if you can zoom into different areas of the image on the LCD.

30. BACKGROUND TYPES

Backgrounds are sometimes the main subject in our pictures, for instance, when photographing a beautiful sky at sunset. More often, background areas are secondary to a main subject, as in a location people picture. While backgrounds may be secondary, they are an important element in practically all photographs. Don't neglect them when evaluating the total image.

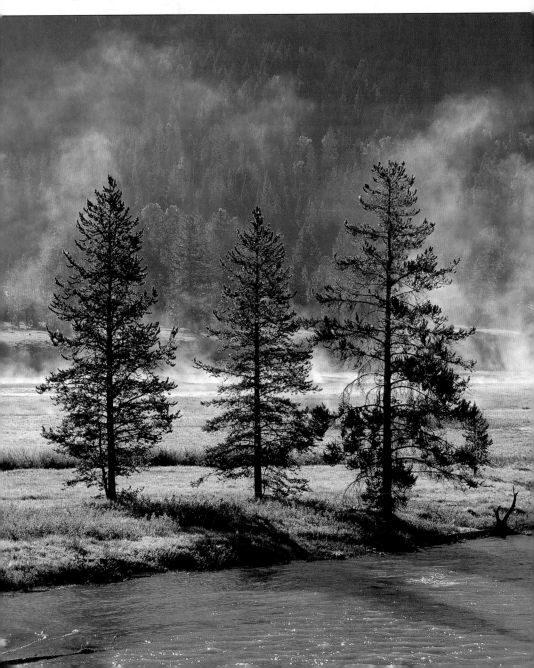

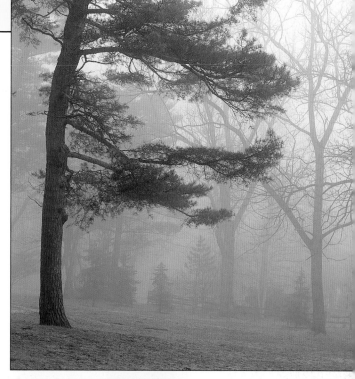

Facing Page—The background, the early morning fog lifting in Yellowstone, was the main reason for taking this picture, with the trees simply being a foreground element to add depth to the image. Right—Fog in the background forms a beautiful backdrop for the evergreen tree in the foreground.

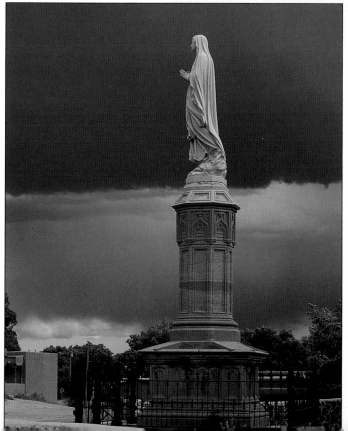

Left—This statue in an Indian reservation was photographed mainly because of the dark sky in the background, which dramatized the image.

65

31. BACKGROUND SHARPNESS

Blurred backgrounds are best when the area does not contribute to the success of the image. Keep the backgrounds completely or reasonably sharp when they are a more important part of the image, when they are exceptionally beautiful, or you want to recognize a location.

You can change the degree of sharpness or unsharpness in the background by changing the lens aperture or by setting your zoom lens to a longer or shorter setting. At a wide-angle setting, the background elements can be reasonably sharp and recognizable. They can be completely blurred and virtually unrecognizable when a telephoto setting is used at the same lens aperture.

Evaluate the effectiveness of the background with every image you capture to be sure it suits your creative vision. If necessary, you can increase the range of sharpness in the computer by photographing two identical images with a tripod-mounted camera; focus the first image for the closer distances and the second for the longer ones, then combine the two with the proper software.

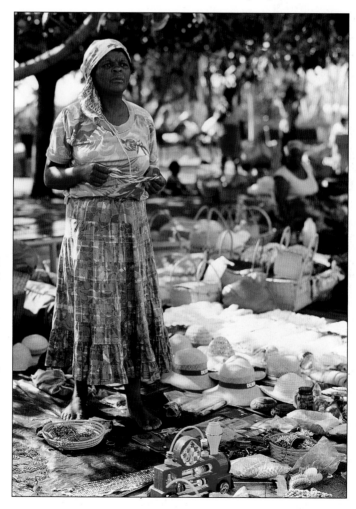

Facing Page—Blurred backgrounds are most effective for most portraits. Make certain that such images are made at large apertures using either the manual- or aperture-priority mode, if your camera offers these options. **Right**—Backgrounds should be reasonably sharp in people pictures where you want to identify the location, as in this marketplace in South Africa.

32. SELECTING BACKGROUND AREAS

Indoors, we can sometimes select the type and color of the background. We can light the background in a specific way to create the desired effect, making it brighter or darker by changing the distance between the subject and background.

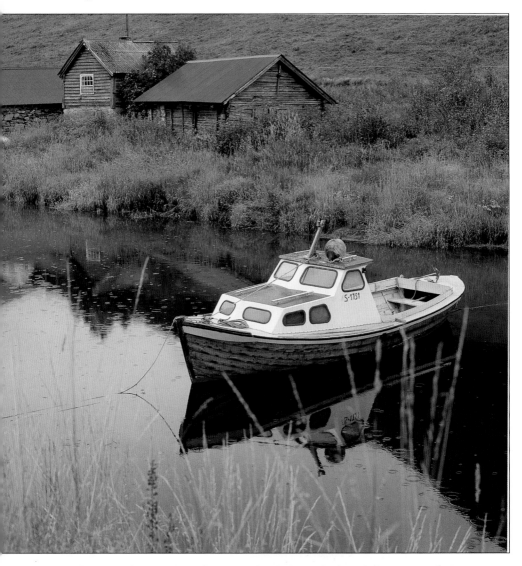

The farmhouse formed a beautiful balance for the boat, photographed on a rainy day in Norway.

Outdoor photography can offer wider possibilities for background types and colors than anything that you might create indoors. The wide selection in the type, color, and brightness of the background offers options for many interesting compositions, a good reason for doing portrait work outdoors.

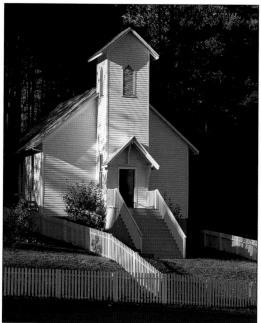

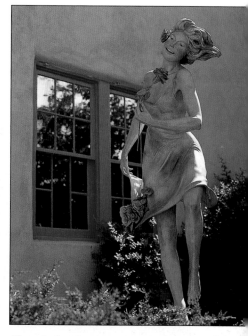

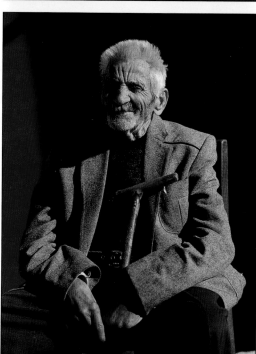

Above Left—The dark wooded area in the back emphasized the beautiful light pattern created on the church by the early morning light. **Above Right**—The window in the background is an important part of the composition, adding a touch of color and a beautiful reflection that forms a balance for the lighted area on the statue. **Right**—Dark areas make wonderful backgrounds for portraits of older people.

33. EVALUATING BACKGROUND AREAS

Whenever time permits, glance over the entire background area surrounding the main subject when evaluating the image in the camera. Do the same again when evaluating the final picture. Make certain that the background area helps to convey the idea that you want to get across in the picture and that the type of background is appropriate for the main subject, or, even better, enhances the main subject. Check that the background colors harmonize or emphasize the main subject without being distracting anywhere within the image area. Do the same with gray tones in a black & white photograph. Make certain that lines in the background help the composition without being distracting, and watch for

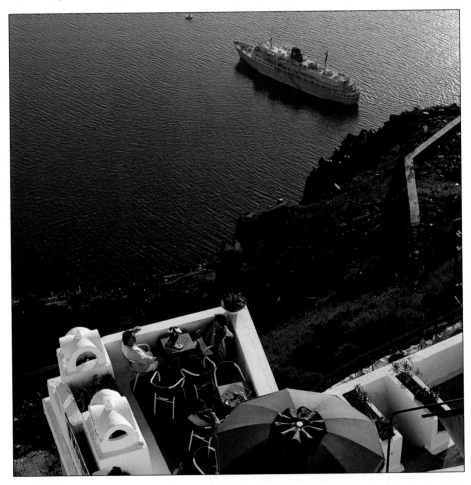

The cruise ship in the background is a most important part of this image and actually was the main reason for taking the image on the island of Santorini in Greece.

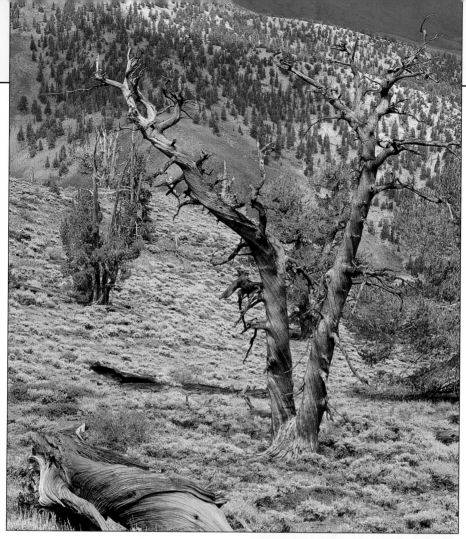

bright, distracting areas anywhere in the picture. Make certain that the maximum image sharpness is on the main subject and that other areas, including the background, have the desired degree of sharpness or unsharpness.

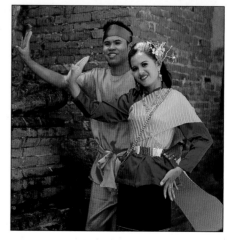

Above—A longer focal length setting placed the bristlecone pines against a small, nondistracting part of the distant hills. **Right**—A shaded, subdued background emphasizes the beautiful, bright colors in the dancer's outfit.

34. PORTRAITS: COMPOSITION

Composing people pictures is not any different from composing other subjects discussed in this book. A person photographed from the front and looking into the camera can be placed in the center in front of a plain background. Such a composition also works in an outdoor portrait if the subject is surrounded by unimportant background elements or repetitive elements that cover both the right and left side of the composition.

However, center placement of an individual in an outdoor setting can look somewhat static. A more dynamic composition results when the person is placed to one side, approximately one-third from the left or right. Such a composition needs a balancing element on the other side. The balancing element, which can be anything (but preferably something of a similar color) is necessary to visually convey the reason why the person is composed to one side. Whatever the balancing element is, it must be visually less important than the main subject. Avoid lines in the background that cross the person's head.

■ GROUP PORTRAITS

A group of three or five subjects always works well. When photographing a group portrait, just place the heads of the different people at different heights.

As noted in lesson 11, working with an even number of subjects makes composition more difficult. However, we usually cannot change the number of people in the group. Groups of two are static but accepted when it involves a bride and groom, or man and wife, etc., probably because we do not expect to see anybody else. If the family group consists of four members, we have to work with four elements, unless you can add a pet. But you can improve such pictures by avoiding an arrangement of two and two—for example, two standing and two sitting. Instead, compose the image so that one subject is sitting and three standing, or vice versa.

When photographing a group portrait, just place the heads of the different people at different heights.

When working with an even number of subjects, you can also look to add an inanimate subject to the photo—perhaps a garden ornament, the white trunk of a birch, a pillar, or flowerbox on a home or a railing. Properly composed, the additional element can then serve as the fifth subject in a group of four.

A wooden ship in Indonesia made a perfect backdrop for this handheld group picture made with fill flash. Two people sitting and one standing also makes for a good composition.

35. PORTRAITS: BACKGROUNDS

People can be related to the rest of the image in two ways: they can actually be a *part* of the background or surrounding area, or the background and surrounding area can be a separate visual element.

If the people are photographed directly in front of a doorway, store window, or wall, all the elements are in one flat plane and the people are actually part of the setting. The background area is predetermined, and everything in the picture is reasonably sharp. The lighting is also pretty much the same over the entire picture area. All you can do is make certain that the entire image area is lit effectively. The aperture and shutter speed settings for such pictures is also unimportant; therefore, the automatic mode works well. Of course, effective composition of the people within the image area *is* important.

In the other approach, the people and background are separated, with the person or people usually being the foreground subject and the middle and background areas falling away behind them. This is not necessarily a better approach but one that provides depth and a three-dimensional feeling to the image. Such a composition also gives you more visual possibilities. It gives you many options for selecting the background area that you want to include by using wide-angle or telephoto settings and shooting from different distances and/or angles. You can determine the degree of background sharpness by changing the lens aperture and by zooming in or out.

You can also make a composition where part of the setting, rather than the person, is in the foreground.

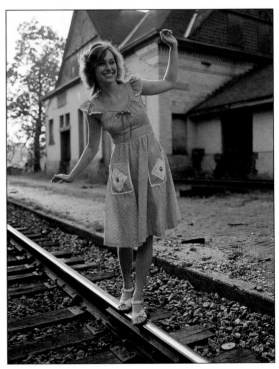

The railroad tracks with the old railway station in the background offered the opportunity for creating a natural portrait of a happy teenager.

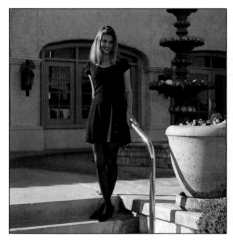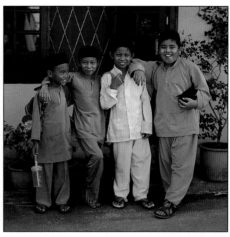

Left—This is a good setting and background for a more elegant portrait. Right—With the boys in Malaysia standing directly in front of the building, the background area and sharpness is pretty much predetermined.

The person or group of people then become the middle or perhaps even the background subject. This can be effective with a staircase, a fence, or some other subject forming a leading line that guides the eye to the people. Be careful that the foreground elements are not overpowering, making the people a secondary element. In such compositions you can create different foreground, middle ground, and background planes with different lighting that enhances the contrast and thus the feeling of depth. Whatever approach you select, make certain that the other elements do not become a distraction.

■ SELECTING THE LOCATION WITH THE PERSON IN MIND

Never select a specific location just because it is beautiful or happens to be convenient. When deciding on a location, think of the type of people being photographed, their nature, and their interest. An old barn, a rustic fence, or other typical country settings are fine for people who like to be considered outdoor types. For people who like flowers and gardens, a colorful garden setting should work beautifully. For a more serious type, you may want to consider the entrance or window of a book store or library (or perhaps a bookcase in an indoor portrait).

36. PORTRAITS: CLOTHING

■ LOCATION AND ATTIRE

Formal outdoor portraits must be discussed with the people beforehand also, because the location must blend with the outfit that the subject plans to wear. The location must harmonize with the style of the image and the style and color of the clothing. Consider a location where all the elements in the picture come together visually. Blue jeans, shorts, and bathing suits call for casual locations, with bathing suits requiring a location where people normally wear bathing suits. Dresses, suits, and fashionable slacks work well in a stylish setting. Children in their Sunday best can look great on the porch or staircase of

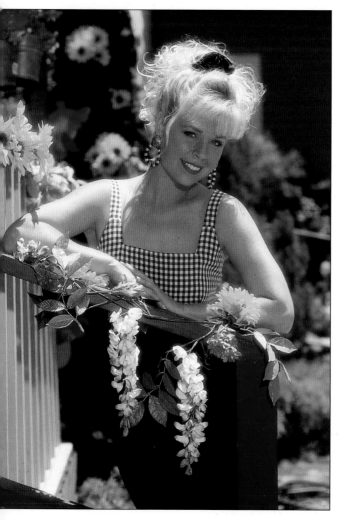

a Victorian building but, at least to me, seem to look out of place in weeds growing over their head (their parents probably would not allow them to ruin their beautiful outfits in those surroundings!).

People's outfits can make or break an outdoor portrait. Teens undoubtedly like to look like the fashion models that they see in magazines and catalogs. This effect cannot be accomplished with everyday outfits but can be created easily by suggesting that the teen wear something that is different and unique. Consult fashion magazines or ask the subject to do so.

Since the flowers added the color, a black-and-white outfit was selected for this location.

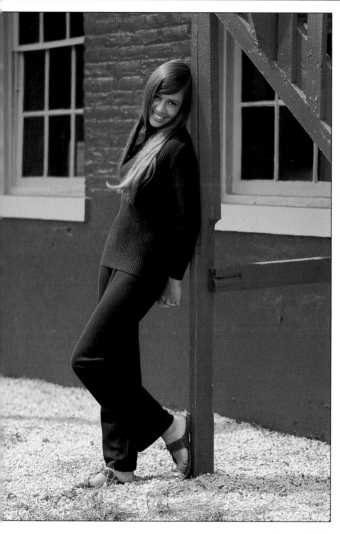

The location shown here was selected because the bright-red color of the building made a beautiful contrast for the model's blue outfit.

■ COLOR HARMONY

Colors in the setting must enhance the picture, not distract from it, and they must harmonize with the colors in the subject's outfit. Colorful backgrounds like a brightly painted house or brilliant fall foliage can be effective if the people are dressed in white, black, gray, or a color that harmonizes with the colors in the setting. If the people select more colorful outfits, subdued colors in the background are likely more effective and more appropriate.

The colors in the subject's outfit can be coordinated with the background in two ways. If the photographic location has been preselected, you may want to tell the person what colors are appropriate. You can also work the other way around and select the location after the clothing selection has been made. In all cases, however, you must be the final judge. If the subject will be photographed in different outfits, you are not likely to be successful if you continue photographing in the same location. The change of clothing will likely call for a change of location.

37. POSING AND COMPOSITION

In addition to location, lighting, background, and the placement of the person or people within the composition, the impact of people pictures is also determined by the way the person or persons are posed. While a snapshot of people looking straight into the camera with their bodies squared to the camera and their arms hanging down may work when photographing an older couple, such a pose will probably not please a wedding couple or young people. They are looking for something that is more unique, looks more polished, and conveys the modern lifestyle and the visual approach that you see in films and on television today.

In the sections that follow, you'll learn how some simple posing strategies can contribute to the strength of the overall composition.

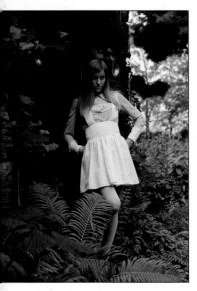

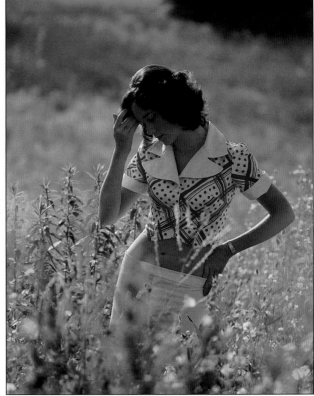

Left—A posed but natural-looking portrait outside a log cabin with graceful lines in the legs, body, and arms. **Above**—This "professional" pose looks completely natural in the location in the existing early-morning light.

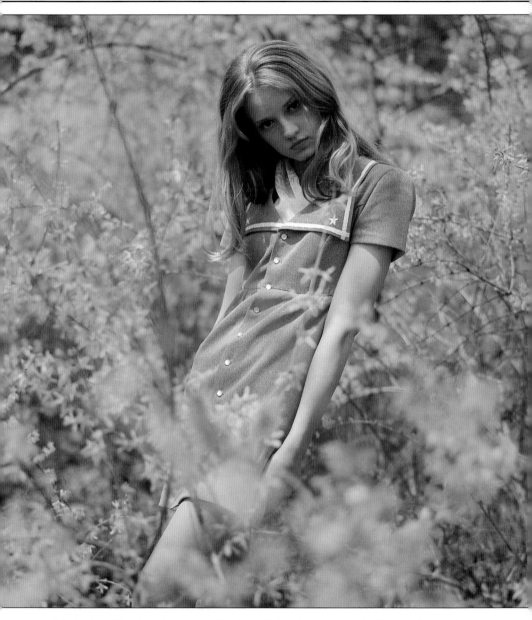

The model's body and head, angled in opposite diagonal directions, produced a dynamic image. The blue dress goes beautifully with the yellow colors in the background.

38. POSING STRATEGIES, PART 1

■ CASUAL OR ELEGANT?

The mood of a portrait—be it casual or elegant—determines how people should be posed in an image. That decision may be yours or the subject's, or more likely, made by both of you together. Positioning the client seated on the ground or in a comfortable chair with his or her hands on the knees is fine for a casual picture. When the subject is wearing more elegant clothing, you want to select a more refined pose and placement of arms and hands. In either type of portrait, the pose must look natural. When I see pictures of children or teens holding roses or candles or reading a book in a field or in front of an old barn, the images seem to me to be artificial. I prefer something that looks more like real life.

> The mood of a portrait—be it casual or elegant—determines how people should be posed in an image.

When working on location, the subject must look completely natural in the setting. You must be involved in the process by suggesting poses that fit the style of the photo and the nature of the people. The final image must appear natural and should never convey the feeling that the photographer told the subject what to do.

■ POSING LEGS

Ask the subject to place their weight on one leg. This allows placing the other leg almost anywhere—to the side, in front, crossed over the other leg, or just touching the ground somewhere. Placing the weight on one leg almost invariably results in a more graceful pose. With the weight on one leg, ask the subject to gently turn, bend, or tilt the body so the body line produces a more graceful

Keeping the weight on one leg allowed the model to come up with a graceful, curved body line. The hat helped for posing arms and hands.

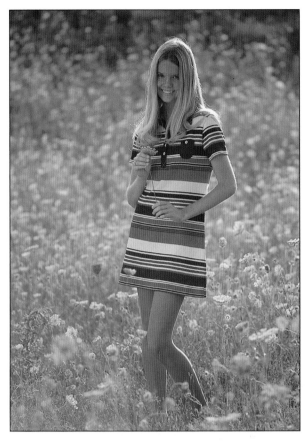

Graceful lines in the legs, arms, and hands, achieved with the help of a flower as a prop, make for a great portrait.

curved and somewhat diagonal line within the composition.

I highly recommend that you not just tell the subject what to do but that you actually demonstrate what you would like them to do. This is true especially for the placement of legs and turning and tilting the body. I have found that this visual approach makes it much easier for subjects to follow suggestions. During this process, let the person know that you are not taking pictures, just examining different possibilities, and that you will let them know when you plan to snap the picture.

This is just a common courtesy that will be appreciated, since many people find it tiring standing in front of a camera never knowing what is happening. By following these guidelines, you'll likely find that the subject enjoys working with you and, as a result, you'll end up with better expressions in the pictures.

39. POSING STRATEGIES, PART 2

■ POSING ARMS AND HANDS

Posing arms and hands comes next. Avoid portraits with two arms just hanging down. Instead, have one or both arms positioned horizontally or diagonally; this is easily accomplished by asking the subject to place one or both hands into pockets or on their belt, necklace, face, eyeglasses, hair, or a hat.

You can also have the subject place their hands on some props. Props are very helpful and simplify producing graceful lines in the arms and hands.

The mood of a portrait—be it casual or elegant—determines how people should be posed in an image.

Avoid photographing the flat front or back of the hands. Ask the subject to turn the hand somewhat in order to produce a more graceful line.

I usually worry last about the head, again asking the person to look into the camera, then turn the head to one side and the other, watching both the pose and the lighting. You must decide whether the subject should look directly into the camera or if a better image will be achieved with the subject looking to one side, or up or down. I often suggest to the individual to tilt her head slightly down, which in my mind adds a graceful look and peaceful feeling. Lastly, you must decide whether the subject should smile or have a more serious expression. The location and the style of the image may determine your decision.

■ THE PROFESSIONAL TOUCH

With some creative planning and some well-executed poses, you may be surprised at how much like professional models "ordinary" people can look. Since most young people like to look like professional models or celebrities, ask your "model" to wear something that is not completely ordinary, something that flatters and enhances their character and at the same time is appropriate for the location.

Most fashion photographers will tell you that it is not the photography but the styling of the clothes, the hairstyle, and the makeup that makes an "ordinary" person look like a professional model. While you probably will not use professional stylists and hairdressers for your photography, volunteers who know something about clothes, can apply good makeup, and understand how to style hair can always be found. A model that I used some time ago came

from a professional modeling agency but, being only thirteen years old, had little professional experience. Fortunately, she came to the shoot with her mom, who used to be a professional model. The mom chose the outfits, worried about the girl's hair, and ensured that the makeup was properly applied.

You may also ask the subject to bring props like sunglasses, gloves, belts, or hats. These accessories can add a professional touch by making the pictures look more like fashion shots. Such accessories also make it easier to find effective poses for arms and hands.

Here is a portrait with graceful lines in the body, arms, and hands that look completely natural.

40. SUBJECTS IN MOTION, PART 1

■ SHUTTER SPEEDS

The shutter speed refers to the length of time that an image sensor is exposed to light. This may vary depending on other exposure settings (such as the aperture, as discussed in lesson 27) or it can be adjusted to enhance the visual effectiveness of the image, in which case it becomes part of the compositional considerations. To take advantage of these creative options, you'll need a camera that allows you to set shutter speeds manually or has a shutter speed–priority setting (see the user's manual to determine whether this option is available on your camera).

■ PHOTOGRAPHING MOVING SUBJECTS

The shutter speed determines how a moving subject is recorded in the camera. Water in any form—in a stream, waterfall, or waves—can be recorded as sharp (as we see it with our eyes) by using a short shutter speed, which may have to be as short as $\frac{1}{800}$ second for crashing waves or the fast-moving water in a waterfall. Alternatively, you can set the camera for a longer shutter speed to record water with a blur that creates the feeling of motion.

Slow shutter speeds give us an opportunity to create images that can only be created in the camera.

The opportunities for creating great blurred-motion images are not limited to water and other typically moving subjects like rides in an amusement park, dancers, athletes in action, children playing, cars, bicycles, and so on. Wonderful possibilities exist everywhere: in reflections on water, trees moving in the wind, and in leaves falling off a tree or being blown around by the wind.

Images with blurred-motion effects are effective visually because we cannot see blurred motion with our eyes. We see everything sharp, even moving subjects. Slow shutter speeds give us a great opportunity for creating images that can only be created in the camera and are different from the way we see moving things.

Images with blurred-motion effects are more likely successful when sharp elements are included in the composition. That is because our eyes are not accustomed to seeing a complete blur; if the entire image is a blur, we may consider it a mistake rather than a creative achievement.

The sharp element can be the rocks in the moving water, the weeds along the stream, or the background area behind the moving dancers or skaters. However, you may also want to keep in mind that the blurred area likely attracts the eye and may become the main subject or main element in the photograph, as it usually should be. Make the composition accordingly.

■ **SHUTTER SPEEDS FOR MOVING SUBJECTS**

The amount of blur produced in the camera depends on the shutter

A slow shutter speed enhances the feeling of a blizzard.

speed, the speed of the moving subject, how far away the subject is, and the angle at which it is moving in relation to the camera. A moving car that is 20 feet away creates more blur than one that is 1000 feet away as it moves over a larger area in relation to the camera. A motorcycle that moves *across* the image area creates more blur than one moving *toward* the camera.

The amount of blur desired in the image is mainly a personal preference. The shutter speed that produces the most effective results is difficult to specify; however ⅛ second to 1 second is a good starting point for water. The amount of blur produced at a specific shutter speed can only be seen on the LCD after the image is captured. After evaluating the shot on the LCD screen, you can then take pictures at other shutter speeds and see which one you like best.

41. SUBJECTS IN MOTION, PART 2

■ PANNING THE CAMERA

With subjects that move, we can create a visually different photograph by moving the camera while the image is being recorded. Moving the camera is a popular approach in sports photography—especially in car, motorcycle, and other kind of races—as well as in wildlife photography when following a running animal.

When moving the camera at the same speed as the subject—a car or animal, for example—the center of interest can be reasonably sharp or at least recognizable with the motion effect created mainly by the blurred background. To make the motion effect visible, the background must have details with different shapes and colors, such as spectators at a race. A plain background does not work. The visual effect can be further enhanced by motions in the main subject that go in a different direction such as the wheels on a bicycle, the legs of a bicycle rider or animal, or the arms and legs of a runner. Shutter speeds for such images range in the neighborhood of $\frac{1}{2}$ second to $\frac{1}{8}$ second.

The panning approach does not work well with nonmoving subjects, as it results in a blur over the entire image area.

Left—A slow shutter speed of $\frac{1}{2}$ second created a beautiful pattern of the reflections. Use the manual or shutter-speed priority mode if it exists on your camera so you can select the shutter speed. **Right**—A fast shutter speed of $\frac{1}{500}$ second or shorter is necessary to record fast-moving water like the Niagara River above the falls as we see it with our eyes.

When recording water with a blur, it is good to have sharp, nonmoving subjects in the picture. We always expect to see something sharp within the picture area.

42. ARCHITECTURAL PICTURES

For accurate representation, the vertical lines of a building must be recorded as parallel, straight verticals. The reason for this requirement is simply that we see most buildings with straight vertical lines. Slanted verticals may be disturbing and give the impression of a technical mistake.

When the slanted lines in a building are created only by the photographer's desire to get the entire building into the picture, the result often looks like a technical mistake, and such

The slanted lines in this temple in Malaysia were the result of tilting the camera. In this case, the converging verticals look completely natural, since this is the way we see it when looking up at the building.

mistakes do not belong in a picture. They detract from the enjoyment of the image.

This does not mean that we can never tilt a camera for photographing buildings or other subjects. There are cases where the slanted lines look completely natural—for example in a picture of a skyscraper or a group of tall redwood trees, when either subject is photographed from a short distance. To see the skyscraper from the street below with our eyes, we must tilt our head to see clearly to the top. When doing so, we see the verticals of the building as slanted lines just like they are recorded in the camera. Photographically you can enhance the slanting of the lines by selecting a wide-angle lens setting and working from a shorter distance.

Again, compositional guidelines must be taken with a grain of salt. I can visualize cases where you might tilt a camera to encourage slanting lines, making them visually more dynamic.

■ STRAIGHTENING VERTICALS

Photographing entire buildings from bottom to top is not always easy. We may have to consider special photographic approaches. Vertical lines are always recorded straight and parallel when the image plane (the back of the camera) is parallel to the vertical subject. When the building must be photographed from street level, this is usually difficult or impossible with wide-angle lens settings without including large foreground areas at the bottom of the image. The bottom area can sometimes later be cropped out in the computer.

You can keep the subject and image plane parallel if you can photograph from a higher angle, perhaps from a building across the street with a lens setting that covers the desired area.

Another option exists if you have the opportunity to photograph the building from a longer distance using a telephoto lens setting. Doing this may

allow covering the entire building without tilting the camera, or at least not tilting it very much.

Producing architectural pictures with straight verticals has become easier with the advent of imaging software that allows straightening slanted verticals in the computer.

This building in New York State was photographed with a long telephoto lens from a field across the street.

43. PANORAMIC IMAGES

Many cameras offer a panoramic shooting mode that allows you to capture images that can later be stitched together in the computer. The necessary software for the stitching process is supplied with some digital cameras. To learn how to use this feature, consult the user's manual.

If your camera lacks a panoramic mode, you can still create panoramic images by photographing separate images in the standard fashion of the panoramic view. To begin, mount the camera on a sturdy tripod, making sure that the camera is level in all directions, so that the horizon is also recorded perfectly level in all the images that are to be combined. Overlap the images by about 20 percent, and make sure that exposure in all images is identical. The matching of the images is usually easier when the photos are made with the standard lens setting rather than telephoto or wide-angle settings.

Next, open your images in a program like Ulead's Cool 360 or ACDSee's Stitcher EZ to stitch together multiple pictures.

■ SPECIAL CONSIDERATIONS

All the suggestions for composition discussed in this book apply to the panoramic format. However, you must pay more attention to recording horizontal and vertical lines perfectly parallel to the picture border, because the long and narrow image format makes the viewer more aware of tilted or slanted lines or subjects.

The stream going from the glacier in Norway on the upper right all the way to the left fills the entire image area from left to right, enhancing the feeling that this photograph must be composed in the panoramic format.

■ FILLING THE PANORAMIC IMAGE FORMAT

A panoramic photo must convey the feeling that the image could only have been created in the panoramic format, that the scene or subject could not have been as effective in a more standard print size. A good panoramic composition must include important elements all the way from the far left to the far right, or from the very top to bottom in a vertical image. There must never be an empty, unnecessary-looking area on either side or on the top or bottom of the image that creates the feeling that it should be cropped off.

■ ARRANGING THE PICTURE ELEMENTS

Evaluate the panoramic composition carefully by checking that it includes important elements all across the long side of the image. If not, consider using a different camera position or a different lens setting to achieve a more effective composition. You need not be too concerned about filling the image along the short side; it is the wide expanse of a landscape, a beach, or the height of a waterfall that makes these pictures effective and different. Such images can be effective without having important elements filling the format in the narrow direction. In the panoramic format we can cover a tall waterfall or a wide landscape without including large areas in the other direction, perhaps avoiding large sky areas that may be unimportant or even distracting.

CLOSING THOUGHTS

Following the guidelines in this book will result in digital photographs that are more enjoyable to you, your family, friends, and travel companions. As a result, you will undoubtedly find more pleasure in using your camera and perhaps start using it not only for personal photography but, in combination with your computer, for more creative attempts as well.

The automated features built into the modern digital camera can help you become more creative in your photographic endeavors. The camera makes most or all the settings necessary to produce technically satisfactory images. As a result, you have much more time to concentrate on the composition and other artistic aspects that produce effective photographs instead of worrying about technicalities. The camera does this for you.

While most digital cameras produce rectangular images in the 3:4 or 2:3 aspect ratio, never feel that your final image must be in the same shape. Feel free to produce the final photo in whatever shape you feel is most effective. For instance, your image may look visually more effective in a more panoramic shape, so cut the top and/or bottom, or the left and/or right side to make it more elongated. Another image may look more effective if the long side is shortened so the picture is more of a square shape. The final photo must always give the impression that the image format is matched to the subject or the mood that you are trying to convey and that the photograph could not be satisfactory in any other image shape.

> The final image must always give the impression that the image format is matched to the subject. . . .

Also, always investigate the possibilities for enlarging a portion of the recorded image, thereby reducing the number of image elements and perhaps also eliminating unnecessary or distracting elements. Evaluate the captured images carefully on the computer screen before you make the final print. You will undoubtedly find that this computer evaluation of your digital images can be as enjoyable as producing the original images in the camera.

INDEX

A

Aperture, 58–63, 66–67
Architectural images, 88–89
Attracting elements, 38–41

B

Background
 area coverage, 56–57
 color and brightness, 36–37, 69,
 70–71
 depth of field, 47, 58–63, 66–67
 evaluating, 70–71
 in portraits, 74–75
 selecting, 68–69, 75
 sharpness, 47, 58–63, 66–67
 types, 64–65
Balancing elements, 24–25
Black & white images, 50–51, 70
Blurred-motion effects, 84–87
Border-cutting elements, 44–45

C

Camera
 lens, *see* Lens
 panning, 86
 steadiness, 8
 tilting, 15
Color
 arrangements, 28–29
 background, 36–37
 balance, 34–35
 harmony, 32, 77
 intensity, 32
 mood, 30–31
 subject, 24–25
Composition
 basics, 6–7
 criteria, 7
 elements, 11
Contrast, 51, 52–53

D

Depth of field, 47, 58–63, 66–67
Distracting elements, 6, 10–11,
 42–47, 70–71

E

Elements, number of, 26–27
Exposure, 52–53, 58–59, 84–87
 aperture-priority mode, 60–61,
 62
 automatic mode, 58
 landscape mode, 61
 manual mode, 58–59, 61, 62
 portrait mode, 61
 shutter-priority mode, 93
 shutter speed, 84–87

F

Flash, subject overpowered by, 47
Focal length, 54–55

H

Highlight areas, 52–53

I

Image evaluation, 9

L

LCD screens, 8–9, 63

Lens
 aperture, 47, 58–63, 66–67
 telephoto, 55, 56–57, 67, 89
 wide-angle, 55, 56–57, 67, 89
 zoom, 54–57

Lines, 14–19
 attracting, 18–19
 centering, 17
 changing orientation, 14–15
 curved, 16
 diagonal, 14
 distracting, 18–19, 70
 horizontal, 14
 placement of, 16–17
 slanted, 19, 47
 vertical, 14

O

Outdoor photography, 69

P

Panning, 86
Panoramic images, 90–91
Perspective, 54–55
Portraits, 72–83
 backgrounds in, 74–75
 clothing selection, 76–77
 group, 72
 location selection, 75
 posing, 78–83

Posing, 78–83
 arms, 82
 casual, 80
 elegant, 80
 hands, 82
 legs, 80–81
Posterization, 51

R

Red-eye, 46
Reflections, 46

S

Shadow areas, 52–53
Sharpness, 7, 8, 24–25, 46, 58–63,
 66–67, 71, 84–87
Shutter speed, 84–87
Simplicity, benefits of, 10–11
Soft focus, 47
Subject(s)
 in motion, 84–87
 number of, 26–27
 placement, 20–23
 secondary, 27
 sharpness, 24–25

T

Technical faults, 46

V

Viewfinders, 8–9
Viewing considerations, 12–13

Z

Zoom lenses, 54–57

CREATING WORLD-CLASS PHOTOGRAPHY
Ernst Wildi

Learn the specialized techniques you need to eliminate photographic flaws and turn out the most refined, artistic image with the countless tips, practical examples, and inspiring images in this book. You'll learn tips for flawless capture, artful composition, posing, and more. Includes comprehensive discussions on ensuring proper exposure, lens selection, the Zone System, digital imaging, and much more. $29.95 list, 8½x11, 128p, 120 color photos, index, order no. 1718.

PHOTOGRAPHIC LENSES
Ernst Wildi

Gain a complete understanding of the lenses through which all photographs are made—both on film and in digital photography. Includes important discussions on lens specifications, angle of view, covering power, lens quality, lens aberrations, and more. Whether you want to better understand your zooms, macros, telephotos, wide-angles, fisheyes, or soft-focus lenses, or want to add to your kit, this is the book for you. $29.95 list, 8½x11, 128p, 70 color photos, order no. 1723.

PORTRAIT PHOTOGRAPHER'S HANDBOOK,
2nd Ed.

Bill Hurter

Bill Hurter, editor of *Rangefinder* magazine, presents a step-by-step guide to professional-quality portraiture. The reader-friendly text easily leads you through all phases of portrait photography, while images from the top professionals in the industry provide ample inspiration. This book will be an asset to experienced photographers and beginners alike. $29.95 list, 8½x11, 128p, 175 color photos, order no. 1708.

BEGINNER'S GUIDE TO
ADOBE® PHOTOSHOP® ELEMENTS®
Michelle Perkins

This easy-to-follow book is the perfect introduction to one of the most popular image-editing programs on the market. Short, two-page lessons make it quick and easy to improve virtually every aspect of your images. You'll learn to: correct color and exposure; add beautiful artistic effects; remove common distractions like red-eye and blemishes; combine images for creative effects; and much more. $29.95 list, 8½x11, 128p, 300 color images, index, order no. 1790.

BEGINNER'S GUIDE TO
PHOTOGRAPHIC LIGHTING
Don Marr

Learn how to create high-impact photographs of any subject (portraits, still lifes, architectural images, and more) with Marr's simple techniques. From edgy and dynamic to subdued and natural, this book will show you how to get the myriad effects you're after—and you won't need a lot of complicated equipment to create professional-looking results! $29.95 list, 8½x11, 128p, 150 color photos, index, order no. 1785.

PROFESSIONAL TECHNIQUES FOR
BLACK & WHITE DIGITAL PHOTOGRAPHY
Patrick Rice

Black & white photography is an enduring favorite among photographers—and digital imaging now makes it easier than ever to create this classic look. From shooting techniques to refining your images in the new digital darkroom, this book is packed with step-by-step techniques (including tips for black & white digital infrared photography) that will help you achieve dazzling results! $29.95 list, 8½x11, 128p, 100 color photos, index, order no. 1798.

THE PRACTICAL GUIDE TO DIGITAL IMAGING
Michelle Perkins

This book takes the mystery (and intimidation!) out of digital imaging. Short, simple lessons make it easy to master all the terms and techniques. Includes: making smart choices when selecting a digital camera; techniques for shooting digital photographs; step-by-step instructions for refining your images; and creative ideas for outputting your digital photos. Techniques are also included for digitizing film images, refining (or restoring) them, and making great prints. $29.95 list, 8½x11, 128p, 150 color images, index, order no. 1799.